EROS
on the Nile

EROS
on the Nile

Karol Myśliwiec

Translated from the Polish by Geoffrey L. Packer

Cornell University Press

Ithaca

Originally published as *Eros nad Nilem*
Copyright © 1998 by Karol Myśliwiec
Published by arrangement with Prószyński i S-ka SA. English translation copyright © 2004
by Cornell University.

First published 2004 by Cornell University Press
Printed in the United States of America

Library of Congress Cataloging-in-Publication Data

Myśliwiec, Karol.
 [Eros nad Nilem. English]
 Eros on the Nile / Karol Myśliwiec ; translated from the Polish by Geoffrey L. Packer.
 p. cm.
 Includes bibliographical references (p.) and index.
 ISBN 0-8014-4000-9 (cloth)
 1. Mythology, Egyptian. 2. Sex—Religious aspects. I. Title.

BL2443.M9713 2004
299'.31—dc22

2003063493

Cornell University Press strives to use environmentally responsible suppliers and materials
to the fullest extent possible in the publishing of its books. Such materials include
vegetable-based, low-VOC inks and acid-free papers that are recycled, totally chlorine-
free, or partly composed of nonwood fibers. For further information, visit our website
at www.cornellpress.cornell.edu.

Cloth printing 10 9 8 7 6 5 4 3 2 1

Contents

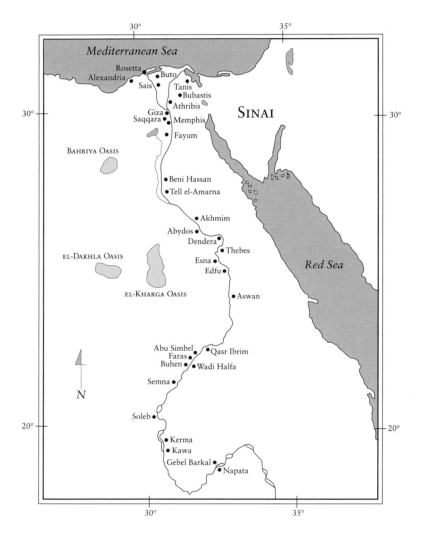

Preface

In the 1960s, a well-known Polish writer visited the archaeological center in Cairo where I was working. He was also known for his avid interest in erotica. He had just returned from India, where he had been influenced greatly by the sensual Hindu art, and had decided to visit the land of the pharaohs. "And what of such matters in ancient Egypt?" he suddenly asked me. This question flustered me somewhat, since my first year in Egypt had been devoted to problems of completely other sorts. In spite of my interest in all aspects of pharaonic civilization, I was not very well equipped to respond to this query. To satisfy my own curiosity, I began from that moment, when the occasion presented itself, to examine publications that might contain information on the topic of eros in pharaonic culture. I was quite surprised by the vast gulf between the amount of information available from Egyptian sources regarding the erotic in the region along the Nile and the almost total lack of publications on this topic.

For many years, all discussion of erotic expression among the ancient Egyptians was suppressed. Their intimate life was represented as an idyll, illustrated in the literary sphere by subtle love poetry and, in the iconographic domain, by representations of Egyptian families—paintings and bas-reliefs—that decorated the walls of the tombs of Egyptian noblemen. On the subject of Egyptian eroticism, Egyptologists had maintained a dis-

creet silence, even in those cases in which they found blatant examples of such matters in Egyptian religion and religious literature. The most striking of these images, which appear sometimes in bas-reliefs and sometimes in sculptures, were simply left unpublished. Entire groups of relics that had been unearthed during excavations were lost. Such was the fate of, among others, a group of figurines discovered in the early twentieth century by a team of English archaeologists, from the so-called chamber of Bes at Saqqara, a sort of sanctuary associated with the cult of fertility, built during the Ptolemaic period in the precincts of the necropolis at Memphis. The walls of this sanctuary, made of mud brick, were decorated with large bas-reliefs representing the phallic dwarf Bes, the protector of pregnant women, standing with a naked woman. Figurines of an erotic nature found in these rooms clearly had a votive or magical character, while the presence of the sanctuary itself, in the midst of the graveyard of pharaohs, dignitaries, and sacred animals, is explained by the close association of fertility with the Egyptian belief in regeneration. Potency was regarded as assuring the preservation of life and therefore played a fundamental role both in daily life and in the sphere of religious concepts in pharaonic Egypt.

In contradistinction to the prudish scholars who, until recently, were engaged in the study of ancient Egyptian civilization, the ancient Egyptians themselves did not consider sexual topics shameful, and did not find any ambiguity in these matters. This view is linked with their conviction that a person is an organic part of nature and develops, together with nature, in a cyclical manner. Just as the earth-mother is impregnated by seeds, sun, and water, and then bears life-giving fruit that expires after the allotted span of time, human beings begin to develop from the moment of their birth and try to extend their own existence, as well as ensure regeneration after death through their progeny. The religious symbol of such regeneration was the mummified figure of the god Osiris, resurrected in the form of his son Horus, the prototype of the pharaohs and guarantor of royal power. The mother of Horus, the goddess Isis, was the Egyptian parental model, and Hathor, the wife of Horus, was regarded as the goddess of love; she was later associated with the Greek goddess Aphrodite. The mythological life of Osiris personified the cyclical patterns of nature, with their yearly repetition. The life of a person was viewed as a parallel, miniature version of this cycle.

To endure in time and space, it was necessary to ensure one's own fertility, which sanctified all means that contributed to this end. Anxiety regarding fertility was a permanent feature of the Egyptian consciousness. This concept is mirrored in both the secular and religious literature of Egypt. In Egyptian mythology, the world of the gods is presented as faithfully mirroring the world of people—their problems, feelings, virtues, and faults, their sorrows and joys. For this reason, mythology is also a valuable source for learning about the erotic life of the ancient Egyptians. However, it should be borne in mind that Egyptian religious beliefs included the realm of magic, which had as one of its primary goals the assurance of success in love and the production of progeny. The erotic experience was regarded as not only a source of pleasure but also an important instrument in the cult of fertility. Thus, the Egyptians had no sense of the erotic as a taboo area; on the contrary, they considered it an important aspect of daily life and spoke about it with complete openness.

Erotic magic made use of numerous symbols, including, for example, votive figures representing now a man, now a woman, with enlarged sexual features, as well as different variants of amorous scenes. These love scenes are sometimes quite explicit in nature, particularly in the case of sketches and drawings executed outside the sphere of official art. On the so-called ostraca (either stone flakes or potsherds), painters often exercised their craft and gave full rein to their vivid imaginations. Similar drawings are sometimes encountered in tombs, particularly those whose decorations were not completed, and on certain papyri.

The best known example of the latter is a papyrus dating from the New Kingdom (second half of the second millennium B.C.E.), which is now in the collection of the Egyptian Museum at Turin—the oldest existing Egyptological collection. Alongside humorous illustrations of animal fables, this unique document also contains a cycle of erotic scenes, which have presented numerous difficulties for interpretation. Because the forms of these figures are often caricatural in nature, and their positions sometimes abstract, many researchers have suggested that they represent artistic wit. Others see in these drawings a satirical look at Egyptian priests. Still others consider this work to be more significant, perhaps an allegory of rituals that were associated with certain Egyptian festivals.

As for the papyrus itself, for more than a hundred years it aroused many

emotions and was one of the relics that was shuttled most frequently between museum exhibit rooms and storage areas. The papyrus was removed from the gallery not only because of prudery but also so that it not distract visitors intending to view the museum's masterpieces of Egyptian art. The Turin Papyrus was known for many decades before it was accorded full scientific publication. The first to do so was Joseph Omlin, a physician and Egyptologist known for his competence in the sphere of describing and interpreting such scenes. His excellent edition of this priceless relic was published in 1971.

Omlin's book made a clean break with the tradition of suppressing sexual aspects of ancient Egyptian culture, as well as the naive tendency to treat Egypt as a culture devoid of erotic elements. From this point on, there was a proliferation of papers and monographs concerning previously unknown sources. The simultaneous development of feminist movements in Western Europe and the United States directed a portion of Egyptological research toward the role of women. Exhibitions dedicated to Egyptian women were organized in several countries. These exhibitions were often associated with symposia that considered the position of women in ancient Egypt. Catalogs of these exhibits, together with published proceedings of the related symposia, provided an ongoing enrichment of the scholarship in this area, and shed new light on intimate life in the land of the pharaohs. Although these various initiatives were predicated more on finding indications of the independence of Egyptian women than on exploring their association with men, inevitably, there was a focus on sexual issues that has enriched our knowledge of Egyptian erotic culture.

It is appropriate that these matters should also be considered in a historical context. In this regard, it would be difficult to separate dynastic Egypt from the reign of the Ptolemies after the invasion of Alexander the Great, and from Roman Period Egypt of the first three centuries C.E.— particularly given the nearly inexhaustible wealth of sources dating from these later periods. Documents written in Egyptian are supplemented by considerable documentation written in Greek. These latter records are significant because the Greek papyri often provide a substantially deeper glimpse into the intimacies of life for the common inhabitants of Egypt than do the texts written in Egyptian. The continuation of many tradi-

tions dating from pharaonic times continued well into the era of Christian Egypt, in the Byzantine period, and then to the invasion of Egypt by the Arabs. Those traditions that did not fade out during the Islamic Period have persisted to the present day. There appear now, among today's inhabitants of Egypt, modified customs and traditions that have their roots in pharaonic times, and which, therefore, date back more than two thousand years. These include, for instance, many customs related to Egyptian marriage.

Ancient Egyptian sources reflect a separate treatment of questions of love and questions of marriage. Although the beautiful reliefs found in the tombs of dignitaries represent the idyll of married life, the refined poetry of love never makes mention of marriage. The female partner in the erotic experience is referred to as the "sister," by which it is certainly appropriate to understand "beloved one." In contrast, sources dealing with Egyptian marriage are documents of a legal nature. Marriages were made under precisely defined contractual conditions that related primarily to the area of property, ensuring that no one, later on, could confuse feelings with facts. Great weight was given to the material protection of the woman in cases of divorce or polygamy—for example, in a situation in which the first wife produced no issue. In the making of such marriage contracts, an active role was played by the closest relatives of the spouses. In this regard also, the practices of pharaonic times are reminiscent of those of present-day Egypt.

It is impossible to separate the customs and manners of ancient Egypt completely from similar aspects of other ancient civilizations. The intermingling of cultures resulting from the prevailing political situation inevitably resulted in the intermingling of various cultural mores. From the second millennium B.C.E. on, there was a particularly marked development of ties between the cultures of Egypt and the Near East. It should not surprise us, then, that one of the most valuable sources of information regarding Egyptian manners and customs is the Old Testament. In the second half of the first millennium B.C.E., particularly with the conquests of Alexander the Great, Egypt entered into the sphere of the Hellenistic *koine*—that is, syncretistic culture—which linked local elements with elements of Greek culture. Morality was also significantly affected by this development—all the more so since Egyptian culture already had

many features in common with Greek culture at the time of their encounter.

In my own practice, I first examined the issue of gender in Egyptian art when I wrote my master's thesis. Among the Egyptian sculptor's models that I considered was a stone tablet with a relief carving representing a hieroglyphic sign with the phonetic value *her*. This symbol has the form of a man's head, viewed from the front. When we began to search for comparable material among hieroglyphic inscriptions decorating the walls of Egyptian tombs and temples, I confirmed—to my own astonishment—that wherever these carved symbols had retained traces of polychromy, the face of the man was invariably yellow. According to the coloristic conventions of Egyptian art, yellow usually characterizes the body of a woman, while the body of a man is represented in red. Why, then, was there an exception to this rule in the case of the symbol *her*, which was usually placed adjacent to (and as a mutual component of a single semantic unit) the hieroglyph *tep*, which has the form of a man's head in profile and is always red in color?

In seeking an answer to this question, I was compelled to enter into various, only weakly illuminated, recesses of Egyptian culture. Our starting point was the fact that the sound represented by this hieroglyph corresponds to the sound of the name of the god Horus, the son of Osiris. In certain exceptional cases, this name is also written with the aid of the symbol *her*. Subsequently, it was found that in the widespread myth of Osiris, and among its many variants, there sometimes appears a homosexual episode that recounts how, as a youth, Horus, the avenger of his murdered father, was raped, by trickery, by the murderer of his father—the god Seth. In some versions of this legend, Horus avenged himself on his own enemy through similar deeds. In Egyptian religious consciousness, however, Horus was viewed as good-hearted, though passive and even sniveling, in contrast to the active, vigorous, sometimes impetuous Seth. But was this episode of such importance to Egyptians that it established the "womanish" color of a hieroglyphic symbol considered to represent the name of Horus? After all, the legend of the rape of Horus appears only in relatively late texts, written on papyrus at the time of the New Kingdom—that is, in the second half of the second millennium B.C.E. As recently as the 1970s, it was still difficult to say just how old and popular

was the conception of an "effeminate" Horus. Although the article I published on this topic is one of the most frequently cited of my works, the bold hypothesis that it contains has occasionally aroused controversy.

Meanwhile, certain archaeological discoveries that were made the same year when the article was published provided unexpected corroboration of my hypothesis. Excavations carried out by French archaeologists in pyramids of the Sixth Dynasty (ca. 2300 B.C.E.), in the southern part of Saqqara, led to the discovery of stone blocks on which were carved previously unknown fragments of the *Pyramid Texts*—the oldest known works of Egyptian religious literature. To the great surprise of archaeologists and historians, the newly discovered sections of these texts contained a homosexual episode that had previously been found only in documents dating more than a thousand years later. So important must this event have been in the characterization of two major gods that it was recorded on the walls of royal tombs as early as the Old Kingdom.

This enlightenment regarding the feminine aspects of the nature of Horus thus sheds light on the choice of yellow for a man's face, which was the hieroglyphic sign considered to be the same as the name of the god himself. In the Egyptian concept, Horus and Seth also personified an antithesis of significantly wider scope. These two gods were regarded as the personification of two opposed, contrasting aspects of human nature that also complemented one another and joined to create a harmonious whole. Various echoings of this juxtaposition occur later, in both the literature and the iconography of Egypt. It is likely that this is the origin of the feminine elements in representations of the Horus child (Harpokrates), particularly during the Ptolemaic Period.

The excavations I was directing in Egypt did not permit me to lose sight of this problem even for a moment. The hieroglyph *her* appears frequently in the inscriptions on the walls of a tomb discovered by our team at Saqqara in late 1997. In some cases, traces of yellow have even been preserved on this hieroglyph.

The tomb of the vizier Meref-nebef, who also bore the "good name" of Fefi, and the "great name" of Unas-ankh, was built at the time when there appeared, on the walls of some chambers within the royal pyramids, the earliest versions of the *Pyramid Texts*—that is, during the transition from the Fifth Dynasty to the Sixth Dynasty, during the reigns of the

pharaohs Unas and Teti. They were served by the "minister" Fefi, not known previously, who is an important historical figure.

However, the tomb of the vizier did more than recall the legend of Horus and Seth, which, at this very time, entered into the canon of the *Pyramid Texts*. The reliefs and paintings that appear on the walls of this tomb consist of inscriptions and scenes that represent the life of the deceased and allow us to peer into the intimate recesses of family life. They show, specifically, that the deceased dignitary had at least four—and, most likely, five—wives, each represented in the funerary chapel. Four of these women form a quartet of harpists, accompanying a group of scantily clad dancers who perform a dance with acrobatic elements. Some of the dancers are kicking up their legs, standing directly in front of the vizier, whose gaze is fixed on them. It would appear that the wives did not satisfy the appetites of the dignitary, however, since, in the most visible place—the entrance to the tomb—there is a representation of the deceased vizier in the company of yet another woman, who is not mother, sister, or daughter. In many of these scenes, the wives of the deceased are represented as figures significantly smaller than him, which is in complete agreement with the conventions of Egyptian art of the pharaonic period. Some of these figures—for example, the wives who accompany the dignitary on a wildfowl hunt in a papyrus thicket—reach barely to his knees.

It would appear that the tomb of the vizier was, after his death, the site of scandalous scenes that were played out between his sons—possibly the children of different wives. Evidence is provided by the intentional destruction of a series of likenesses of his sons except for the one that bears the "good name" of his father, Fefi. One of these scenes shows him turning his head and smiling in a friendly way toward his brother, of whom there remains only the negative imprint of a relief sculpture. Most likely, the younger Fefi was victorious in some family conflict; however, the tomb, with its damaged decorations, was soon walled up, surely by family members who feared a scandal. The facade of the tomb was hidden for more than two thousand years by a multilayer "cloak" composed of stones and brick, which protected the tomb from penetration by thieves.

The youthful Horus (that is, the Hellenistic Harpokrates), of effeminate features, is again recalled by a discovery we made in ancient Athribis (present-day Tell Atrib), in the Nile Delta, where, beginning in 1985, a

Polish-Egyptian archaeological mission began to carry out "rescue" excavations. These excavations unearthed priceless and unique archaeological material, which enhanced our knowledge of daily life at the other end of the history of ancient Egypt—that is, during the period of decline that occurred during the reigns of the Ptolemies and, subsequently, of the Roman emperors. Among the countless terra cotta figurines found amid the former workshops of potters and sculptors and coroplasts, particularly noteworthy are the representations of Harpokrates, which are surprising in their variety and wealth of iconographic types. The distinguishing feature of the male figurines—not only of Harpokrates but also of other Egyptian and Greek deities, and of common people—is, frequently, an enormous phallus. In this vicinity were also found figurines of women, sometimes pregnant, either naked or exhibiting their genitals, which permits one to suggest an association with a local cult of fertility. Such a cult was generated, in the Ptolemaic Period, by an ongoing process of symbiosis involving ancient Egyptian traditions and imported Greek elements. The Egyptian harvest god Osiris is associated here with the Greek god Dionysus, who became the dynastic deity of the Ptolemies. Isis and Hathor were identified with Aphrodite. Harpokrates and Bes, deities of Egyptian origin, were sometimes adorned with the Dionysian ivy. Harpokrates often bears on his head the crown of the pharaohs, but he is clad in a Greek cloak and tunic. Such elements of syncretistic Hellenistic culture appear not only at Athribis—where, after the conquest of Egypt, some soldiers of Alexander the Great settled—but also throughout the entire country.

At Athribis, a cult bearing features of both Dionysus and Osiris was centered in the area of the public baths, where we found the greatest number of votive objects of an erotic nature. Even beautiful ritual vessels, made of a variety of materials, were often decorated with appliqués representing scenes of love. Although some scholars would like to see in these baths, which were built during the reign of Ptolemy VI (mid–second century B.C.E.), a kind of public bawdy house, it appears, instead, that they were meeting places for a Dionysian company reminiscent of the Greek *stibadeion* ("little nest")—a location where the cult of Dionysus expressed itself, particularly with sculptures of an erotic type. It is no wonder that the designated meeting place was the baths, since the ritual

ablution, which is frequently associated with the domain of magic, was universal in both Egyptian and Greek culture. It seems plausible that in the case of this cult (records of which have been found in Ptolemaic Athribis), the erotic element was closely linked with the cult of fertility. All this evidence indicates that the full enjoyment of life, including its erotic aspects, was an essential element of the religious feasts both in pharaonic Egypt and also later, during the Greco-Roman Period. This enjoyment of life was a part of the *perpetuum mobile* of nature, which represented the cyclical development of the entire natural world.

EROS
on the Nile

Introduction

Erotic themes—and their correlate, sexual themes—occupy an important place in the religion of ancient Egypt. Owing to the numerous written and iconographic sources that have survived to the present day, many of the erotic motifs of Egyptian mythology are known. Significantly less well known, however, are similar aspects of religious ritual, although even here there appear, at least in symbolic form, certain sexual elements. Mythological texts, written on papyrus or carved on stelae or on the walls of tombs and temples, and the scenes with similar thematics that accompany them provide a basis for our knowledge in this area.

However, the sources are still very fragmentary. It would be difficult to trace with any precision the development of sexological concepts in Egyptian religion from its origins in the fourth millennium B.C.E. to its collapse in the first centuries C.E. As in the case of the political history of this region, the lack or inadequacy of first-hand accounts from several periods, even some lengthy ones, creates a corresponding "black hole" in our knowledge of the religion of pharaonic times. Most of the surviving sources date from periods when the Egyptian state was politically strong, periods that were also distinguished by the originality of their culture-generating elements. Such is the case for the periods of the third and second millennia B.C.E., which have been divided by historians into the Old,

I

Middle, and New Kingdoms. Substantially less well known is the so-called Late Period, which, in the first millennium B.C.E., preceded the reign of the Ptolemaic Dynasty (third to first centuries B.C.E.) and the Roman Period (first to fourth centuries C.E.). In this Greco-Roman Period, religious traditions of the pharaonic epoch continued to develop, often in symbiosis with the beliefs of the Greeks. The syncretistic religion of Ptolemaic Egypt, which spread to different parts of the Roman Empire, was popular across the entire Mediterranean world until the dawn of the Byzantine era. Many mythological texts and scenes preserved in the temples and tombs of Greco-Roman Egypt remain, to the present day, the only source of knowledge of certain aspects of Egyptian religion, although clearly indicating an earlier pedigree.

Equally incomplete is our knowledge of the geographical distribution of the belief systems of ancient Egypt. The individual religious centers of the country created their own theologies, which frequently incorporated several elements of the theologies of competing centers. The beliefs of the earliest periods—specifically, the elements of the religion practiced in Upper and Lower Egypt at the end of the fourth millennium and the beginning of the third millennium B.C.E., or during the development of the Egyptian state, through the unification of these two territorial entities—have come down to us almost exclusively via the attributes of their later development. Regarding our present topic, there is little to note here beyond the fact that the cult of fertility, which found expression in figurative art, was already firmly established at that time. A sign of this fact is the tendency to emphasize the sexual parts of the human body—for the man, the phallus in an erect state; and for the woman, wide hips and shapely, carefully modeled breasts.

The theology of the most important religious centers is known to us only in its mature form, which bears traces of a prolonged prior development. During the Old Kingdom (Third to Sixth Dynasties), for example, the capital of the unified kingdom was Memphis, situated at the meeting point of Lower (northern) Egypt and Upper (southern) Egypt, at the south end of the Nile Delta. In the vast cemetery of Memphis, which extended for several dozen kilometers along the west side of the Nile, in the vicinity of present-day Cairo, there survive numerous tombs of the pharaohs (pyramids) and dignitaries (mastabas) of that era. The walls of

these structures are decorated with polychrome bas-reliefs, among which is the oldest epigraphic source of knowledge of the religion of dynastic Egypt—the *Pyramid Texts*, the earliest known religious texts of ancient Egypt. These texts, which are carved on the walls of funerary chambers in pyramids dating from the end of the Fifth Dynasty (i.e., from ca. 2345 B.C.E.) as well as from the Sixth and later dynasties, constitute literary works composed on the basis of various earlier texts. Although they are preserved in the structures of the Memphite necropolis, the *Pyramid Texts* are primarily a compendium of the theology of Heliopolis, the oldest of the three major theologies of pharaonic Egypt.

Heliopolis, situated fairly close to Memphis, on the east side of the Nile, was the central site of the cult of the sun god. Very little has survived at either Heliopolis or Memphis, which enhances the importance of the *Pyramid Texts* in providing knowledge of the religious culture of the land of the pharaohs in the first of its three great epochs. There is a paradoxical overlap of information regarding the religion of Memphis that we know of through a text recorded only sixteen centuries later (on the so-called Shabaka Stone), though it is unclear whether the author of this stone copied a substantially earlier theological text.

The available sources that have been broadly outlined here do not, therefore, allow for study of either the diachronic development of Egyptian religion (in regard to the sexological aspects of mythology) or the full extent of the differences between individual cult centers. A religion that embraces a chronological span of nearly four thousand years and covers a large geographical area, situated along the Nile and at several oases, is treated in the present work as a single entity, with emphasis on only its most essential differentiating features.

I

Major Theological Systems

The cult of fertility, which was dominant in the primitive religious ideas of Nile valley residents at the end of the Neolithic Age, was mirrored in many ways in the Egyptian religion of the pharaonic period. The symbol of fertility was the bull, and its guarantor, for the entire country, the pharaoh. The ruler was therefore identified with the life-giving male vital force. One of the most popular epithets for the king was "mighty bull," which was often the beginning phrase in his lengthy titulary. This epithet was also part of one of the five royal names, referred to as the "Horus name." The god Horus was regarded as the prototype for all the pharaohs; his zoomorphic incarnation was the falcon. Like the majority of the deities of the polytheistic Egyptian religion, Horus was represented not only in animal form but also in human form. He appears most often as a man with the head of a falcon.

The three greatest religious centers of ancient Egypt, which created original theological systems, were Heliopolis, Memphis, and Hermopolis. The dynamic element in each of these theological systems is cosmogony—the explanation of the formation of the world of gods and people. The initial act of creation, and the breeding of the first gods, is the fundamental problem of theogony. In each of the three theological centers, this problem was resolved in a different way.

HELIOPOLIS

In the Heliopolitan system, known from both the *Pyramid Texts* and later sources, the primeval god was Atum, one of the forms of the sun god Re. Atum emerged from the initial chaos, which was conceived of as a dark, motionless ocean called Nun, and appeared on the primal mound to beget the first pair of gods. In the *Pyramid Texts*, Atum is actually identified with the primeval mound itself and bears its name—Benben. As a solitary being, the primeval god was compelled to play the roles of both the first male and the first female. He created the first pair of gods through an act of masturbation. Using his hand, Atum brought his phallus to an erect state and then swallowed his own ejected sperm. The role of vagina was played by his mouth.

The fruit of this act was the first pair of gods: Shu, who personified the air, and Tefnut, who personified moisture. Shu was spat out of Atum, and Tefnut was coughed or vomited out. Next, Atum embraced his children with his arms to transfer to them his own soul (*ka*)—his essence.

The first pair of gods then begat, by natural means, the sky goddess Nut and the earth god Geb. Nut and Geb, in turn, were the parents of two pairs of gods: Osiris and Isis, and Seth and Nephthys. These deities, together with Atum, comprise the group of nine Heliopolitan divinities, referred to most often by the Greek term *Ennead.*

The Heliopolitan myth concerning the creation of the first gods underwent major revisions over the centuries. Different versions of this myth are found, for example, in the so-called *Coffin Texts* (texts written on the walls of wooden coffins in the times of the Middle Kingdom) as well as in the *Book of the Dead*, the most popular work of religious literature of the New Kingdom, which is found most often on papyri and, more rarely, on the walls of tombs. The most extensive known literary version of this myth is found in the Bremmer Rhind papyrus, dating from the end of the fourth century B.C.E.

An expanded version of the Heliopolitan theogony, which appears in the *Coffin Texts*, has a more refined form. Here, the primeval world consists of several deified elements: the primeval ocean (Nun), infinity (Huh), wilderness (Tenemu), and darkness (Kuk). The weary Atum is swimming in Nun, out of which, in a self-generating act (sometimes re-

ferred to as "self-consolidation"), he raises himself. In this version, there is no longer any question of the primeval hill amidst the ocean. Almost simultaneously with the autogenesis of the primeval god there arise from him Shu and Tefnut, who, together with Atum, form the first divine trinity. A triad of deities, united by family bonds, is one of the most widespread concepts in Egyptian religion.

Several fragments of the *Coffin Texts* intermingle into the legend of the creation an element of consciousness that was identified by the Egyptians with the heart, as well as a spiritual element connected with the notion of *akhu*. Here, the children of Atum personify the cosmogonic principles of life and truth (order) as well as eternity and infinity. In another version of creation, also known from the *Coffin Texts*, the initial gods of the theogonic cycle are Hekau (god of magic power and creative energy), Hu (the spoken word), and Sia (reason and creative intelligence).

According to the same texts, the primeval god is also the creator of people and all other beings. Millions of creatures—referred to here as souls (*ka*)—issued from his mouth, while humans arose from the tears shed by his eye. This eye was supposed to protect the two children, Shu and Tefnut, who were raised by the goddess Nut and the god Nun. It was thought that these events took place even before the creation of the sky and the earth. Such a concept places the goddess Nut in a particularly difficult theological and chronological position, since she would be bound to have existed in some "pre-eternity," even before the creation of the sky. This inconsistency, together with the diversity of other theological concepts found in the *Coffin Texts*, indicates clearly that we are dealing here with a type of compilation, in which elements of various local theologies intermingle and sometimes coalesce into a syncretistic whole. For the first time, there appears a tendency to supplement a purely biological vision of creation with abstract elements relating to certain aspects of human nature, such as intellect, feelings, will, and speech.

Further differentiation of cosmogonic concepts appears in the New Kingdom, reflected above all in the *Book of the Dead*. Here, the act of creation distinctly separates precosmogonic primeval times from the times when the sun god ruled. The sun god appeared on a primeval mound situated in Hermopolis. We see here most markedly the influence of Hermopolitan theology.

An unconventional version of Heliopolitan theogony is found in one of the texts of the Late Period, carved on a stone naos from Saft el-Henna that dates from the Thirtieth Dynasty. Geb is represented here as incestuous: He has deposed his elderly father Shu, raped his own mother, Tefnut, and seized power. This is one of many instances of intimate relations between related figures of the Egyptian pantheon. In this regard, Egyptian theologians exhibit an element of immoderate fantasy, and we search in vain for any rigorous consistency. The solitary creator Atum was, in later times, associated with various goddesses, considered as his mother, consort, or daughter. Four of these goddesses (Iusaas, Nebet-hetepet, Hathor, and Nut) could even have played each of these roles.

The Heliopolitan concept of a sun god who emerged in an act of autogenesis as a primeval hill from primeval chaos to create, through masturbation, the first pair of gods had various religious implications, which were throughout manifested both in some beliefs and in various cults. The primeval mound was the subject of particular veneration in Heliopolis. It was identified with a stone or earthen mound, known as Benben, which was situated in a temple called the "house of the phoenix." It can be assumed that this relic had an approximately pyramidal shape, since a similar word, of feminine gender, defined both the pyramids that were a part of the royal funerary complexes and also the pyramidia that crowned obelisks. The same word also defined bread molded into a conical shape that was used for cult purposes. In later times, the symbolism of Benben was expanded to include, for example, the pair of obelisks representing the sun and the moon that decorated Egyptian temples.

Masturbation as a creative act is featured extensively in Egyptian religious iconography from various periods. The very hand used by Atum during masturbation was considered to be sacred. The practical nature of Egyptian theologians led, at times, to the identification of masturbation with goddesses who, in a certain sense, were associated with the primeval god in the role of female partner. This tendency is found for the first time in coffin inscriptions from the First Intermediate Period. In these inscriptions, whenever there appears a sentence mentioning gods with their female partners, the Heliopolitan "onanist" appears in the form of "Atum and his hand." In later times (New Kingdom), this hand is identified with two anthropomorphic goddesses—Iusaas and Nebet-hetepet—who were

worshiped in Heliopolis. In Egyptian the name Nebet-hetepet signifies Lady of Satisfaction. These goddesses were identified, in a syncretistic unity, with the goddess Hathor and with the hand of the creator-god. A similar association has also been found regarding other popular female deities, such as Mut and Isis. In offering formulae (standard inscriptions concerning funerary offerings), the hand of Atum is enumerated beside the eye and the uraeus (a cobra decorating the brow) of this god. Magical texts dating from the Late Period (among others, those carved on the statue of Djed-hor found at Athribis) ascribe to this hand the function of calming rebellions, thereby enhancing the notion of "satisfaction" with the aspect of "appeasement." The notion of the "hand of the god" became, in time, an epithet that was bestowed on queens, princesses, and priestesses—and in particular, the so-called god's consorts of Amun, who were ascribed to the Theban creator-god in the role of female partner. These consorts, who were a living symbol of the connection of the royal element with the divine element, played an important role in the dynastic politics of the rulers, particularly during the Late Period. The magical significance of the hand of the creator also led to the development of a musical instrument with the shape of an elongated palm, sometimes having a handle in the shape of the head of the goddess Hathor; this instrument was a kind of clapper, made most often of wood or ivory, producing sounds by striking together two identical hands.

The Cult of Male Fertility

The symbolism of masturbation as a creative act left its mark particularly on the iconography of male deities. There are frequent ithyphallic representations of various gods with one hand on their phallus, particularly in the case of those creator-gods who were regarded as guarantors of fertility and abundant harvests. An entire procession of such deities can be seen in the reliefs that decorate the walls in the sanctuary of a temple dating from the Twenty-seventh Dynasty and standing in the el-Kharga oasis. Here, the large, erect phallus is an attribute not only of these anthropomorphic deities but also of several zoomorphic deities, who are also provided with human hands, one of which rests on their male member. In an outburst of zeal, the artist has even added an ithyphallic female

deity, shown with an erect phallus; this goddess has the head of a lion, and her name may be read as either "The Great Mut" or "Mother of the Great Ennead." Iconography of this type would appear to be more consistent with the warlike goddess Neith, who was worshipped at Sais as the primeval deity and who stood at the head of the Saite pantheon, than with the goddess Mut.

The phallus, as the part of the body that ensures procreation, was an object of particular attention in Egypt. Already in the earliest historical periods, men wore, for protective purposes, a leather or linen sheath attached to their belt, with only the scrotum exposed. During the Dynastic Period, the phallus of a deceased man was embalmed and wrapped in resin-saturated bandages, causing the phallus to remain stiff, sometimes even erect, as was the case with, among others, the mummy of Tutankhamen (fourteenth century B.C.E.), found in the tomb of this Egyptian ruler. Several mummies have been found to have an artificial phallus, made of a similar substance, in an erect state. By this means, the deceased conformed to the mummified shape of the god Osiris, ruler of the underworld, symbolizing simultaneously regeneration and its mirroring by nature. As in temporal life, in posthumous life the man had to ensure perpetuation through his progeny. Safeguards against impotence included various aphrodisiacs, as well as votive donations in the shape of a phallus, phallic statues, and even figurines representing groups of people carrying a disproportionately large male member. Meanwhile, the sexual prowess of the deceased was supposed to be ensured by means of phallic-shaped amulets that were placed in the tomb with the mummy, most often between his legs. The same goal was attained through the use of various magic spells, which are already present in the *Coffin Texts*. The male sexual organ had various names in different texts, among which also appear certain metaphorical and descriptive designations, such as "hoe," "firm one," and "handsome one." Written descriptions of the sexual organs, as well as their representation in art, were considered to be a completely natural matter—devoid of emotive aspects, and ethically neutral.

Ithyphallic representations of gods are widespread in Egyptian religious iconography. In particular, some of the most ancient gods, who were associated in various ways with the cult of fertility, are generally represented with large, erect phalli. This representation applies above all

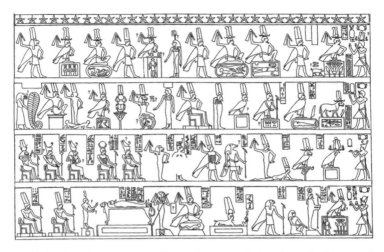

Primordial god in the creative act of masturbation. Relief on the wall of the temple of Darius at el-Kharga oasis.

to Min, whose name, written with the characteristic emblem of the god, appears on tablets from the Predynastic Period that are associated with the Nagada culture (end of the fourth millennium B.C.E.). In the Early Dynastic Period (ca. 3000 B.C.E.), several colossal limestone statues of Min were erected at Koptos, a locality in Upper Egypt that was the primary center of his cult. In later times, Min is often represented, in reliefs and in statuary, as a man with joined legs, holding a flail in his right hand and, with his left hand, embracing his phallus. The left hand of this god

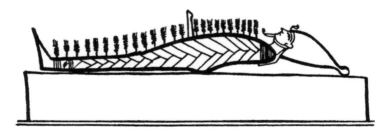

Ithyphallic "sprouting Osiris." Drawing in Papyrus Jumilhac, Greco-Roman Period.

The ithyphallic Min, god of fertility, and his attribute, lettuce. Relief in the temple at Redesia, Ninteenth Dynasty.

is visible only in sculpture in the round, since in two-dimensional representations of Min, his torso covers this hand. This gesture, which is reminiscent of that of the primeval creator-god, identifies Min as a guarantor of fertility.

The head of Min is adorned with a crown of two falcon feathers, sometimes completed with the representation of a solar disc. A ribbon hangs down from the back of the crown. Like other anthropomorphic gods, Min was depicted with an oblong false beard, turned up at the tip. He is often characterized by two attributes: a bundle of lettuce, and a cylindrical or conical hut decorated with bucranium and with a spirally twisted band. The shape of these huts has led some Egyptologists to conjecture that Min may have a foreign origin, owing to a similarity to structures typical of the land of Punt, whose precise geographical location has not yet been established (most likely, in the vicinity of present-day Soma-

lia). Egypt was united with Punt by friendly relations characterized by, for instance, great commercial expeditions to that land undertaken by the pharaohs.

In the Hellenistic Period, various male deities linked with the cult of fertility possessed phallic characteristics. Among the terra cotta figurines discovered by the Polish-Egyptian archaeological team in the Ptolemaic strata of Tell Atrib (the ancient Athribis, situated 50 km north of Cairo) were representations of Bes—a bearded dwarf with a large phallus and a crown of feathers on his head, the guardian of women during childbirth—and of a naked Harpokrates (the Horus-child) with strongly emphasized sexual organs. Several effigies of a similar nature found at this site represent Greek gods. One of the small terra cotta oil lamps has the shape of a seated, naked Silenus, whose long phallus functions as a lamp burner. The characteristic features of Bes and Silenus are merged in figurines representing a seated phallic dwarf with negroid features and a bald head crowned with two lotus buds. The face of this dwarf bears a rapturous expression.

A relief found on another terra cotta figurine, only fragments of which survive, represents two naked men standing side by side. The monstrous phallus of the older man hangs like a garland between his legs and is held in one of his hands. Of particular interest is a bas-relief impressed on a clay figurine representing an elephant. Visible on one side of the elephant is a merry Bes, dancing between two huge roosters, while on the other side, two naked men, with phalli long enough to reach the ground, are dancing. A similarly huge male member is possessed by a man clad in a Greek tunic, who is carrying in his arms a bunch of vegetables, which may represent lettuce. Since the head of this figurine has not survived, it is not known whether this is a representation of one of the gods or of some other figure.

Lettuce, which is depicted in the form of a tall garden plant, was one of the most common of the Egyptian aphrodisiacs and is also an attribute that confirms the position of Min as a fertility god. A field of lettuce usually depicted near the god in reliefs has the form of a rectangle divided into rows of smaller beds and appears in a horizontal projection. Emerging from its upper edge is a vertical row of plants, viewed in profile. In joining these two different perspectives, the Egyptian artist has

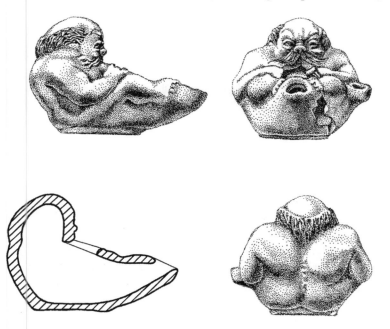

Terra cotta oil lamp modeled after the Greek god Silenus, companion of Dionysus, who was identified with the Egyptian Osiris. Ptolemaic Period, from the excavations at Tell Atrib.

adhered to the principle of "objective information," consisting in the representation of that which the creator of this drawing knew objectively—not that which was perceived by his own eye in foreshortened perspective. This permits one to assume that this "aspective" (in Egyptological jargon) representation of a field of lettuce was regarded as an important iconographic element, emphasizing the essential nature of the god of fertility. To Min was also given the epithet "the one who is in front of his fields."

Festivals in Honor of Min

The particularly important role played by Min in the life of Egyptian society, from the very earliest historical periods, is attested to by numerous

written sources containing accounts of the great festival that was celebrated annually in his honor. During the Early Dynastic Period, this rite consisted primarily of the "birth of Min," which was associated with the making and the consecration of a statue of Min. This rite became so important that, in the royal annals of the Old Kingdom (carved on the so-called Palermo Stone), the "making of the statue" is sometimes mentioned as the event of the year and is characteristic of this period. In later times (Middle Kingdom), this ceremony was merged with the feast of the "going out of Min," about which we have precise information, obtained both from texts and from scenes carved on the walls of the funerary temples of Ramesses II and Ramesses III (New Kingdom), situated in western Thebes.

This feast was primarily a harvest festival, taking place during the harvest period in the first month of the season known as *peret* (winter). This festival lasted for many days and consisted of several ceremonies. The king, his family, and the royal court all took part in the event. The celebrations began with a procession that made its way to the temple of the harvest god, Min. We see in this procession the pharaoh, wearing the *khepresh* crown (a kind of tall helmet, also known as the "blue crown," which usually covered the head of the pharaoh during the royal coronation and in celebration of military victories), being carried by his subjects in a ceremonial litter. Other participants in this procession included relatives of the pharaoh, priests, musicians, fan bearers, and soldiers, all represented with feathers plaited into their hair, intended to resemble the life-giving lord of bountiful harvests. In the next phase of the festivities, a priest bearing the title *kheri-hebet* made an offering to an ithyphallic god with the syncretistic name of Amun-Re-Kamutef. This deity was identified with Min and was represented in a similar manner. The king, wearing the crown of Upper Egypt (also known as the "white crown"), then led the procession, which also included an effigy of Min that had been carried out from the sanctuary. The procession advanced to a staircase, by which it gained access to a threshing floor or a stall situated at a higher level. This ritual must have been especially important, since it provides the name for the entire ceremony—the "climbing of Min onto the stairs."

Under a canopy strewn with stars, there proceeded, together with the

rest, a white bull—one of the many hypostases of the animal worshipped in Egypt as the embodiment of fertility. Accompanying the bull were effigies of deceased pharaohs, among which were sometimes even the effigies of particularly meritorious rulers from several hundred years before. These were the addressees of a cult similar to that reserved for both god and royal *ka* (spiritual double). In their honor, hymns of praise were sung. The presence of ancestral statues is one of the many features of this ritual that point up the act of procreation as a precondition for maintaining the continuity of the species. These statues co-created a dynastic version of the biological cycle of death and rebirth, which found its correlative in the phases of the yearly cycle of the natural world, the culmination of which was expressed in this very festival. In the final episode of the ceremony, the king walked around the "stairs" and released a single dove (or goose) into each of the "four quarters of the world." The task of these birds was to proclaim to all people that Horus, the son of Isis and Osiris (that is, the pharaoh), took into his hands both the white crown and the red crown, signifying a reign that embraced all of Egypt. After having carried out this act of political-theological propaganda, the king closed the ceremony by symbolically cutting a sheaf of grain in front of the sanctuary of Min and making an offering of it to Min, in thanks for a bountiful harvest. The ruler himself was given one stalk of this grain. This ritual cutting of the sheaf was carried out with a gold-sheathed copper sickle. Metaphorically, this ceremony represents victory over the enemies of the god and the king. Since iconographic sources represent the royal wife as the only woman taking part in this ceremony, she was presumably regarded as the personification of the female element that completed the universal symbolism of fertility and bountiful harvests.

The festival of Min, or some other ceremony of a similar nature, should probably be associated with two ritual episodes that are illustrated by two different scenes carved on the walls of Egyptian temples. The first scene represents a ceremony referred to as the "ascent to Min," while the second scene shows a driving of four calves. In the ascent of Min, a portable tent was erected by people whose heads were decorated with feathers. The scaffolding consisted of poles leaning aginst a vertical pillar, connected by lines of ropes, and sheathed with animal skins. This tent represented the chapel of the god, and within it homage was paid by a

nomadic tribe, probably inhabiting a region in the vicinity of Wadi Hammamat and Koptos, where Min enjoyed particular popularity. The most complete illustration of this ceremony is sculpted in relief on the walls of the festival chapel of Senusret I (Twelfth Dynasty, Middle Kingdom) at Karnak.

The second of these rites—the driving of four calves by a ceremonially attired ruler—finds its iconographic expression in a scene that is a part of the classical repertoire of the bas-reliefs in Egyptian temples. The king, holding each of the four calves by a rope attached to its leg, is shown leading them to a god, who, in the Theban temples of the New Kingdom, is the ithyphallic Amun-Re or Amun-Re-Kamutef, who is always represented in a way similar to Min. Despite the fact that the nature of the god of fertility was assimilated by a variety of local deities (who appear in later versions of this scene), the original form of this ritual did not change fundamentally from the times of the Old Kingdom up to the Greco-Roman Period—that is, for a period of some three thousand years. This scene is given various meanings on the basis of accompanying inscriptions in temples of the Ptolemaic and Roman periods. Some of these inscriptions speak of the driving of calves across the threshing floor of the god, for the purpose of threshing the grain. In this case, the king would incarnate a good shepherd who, as a reward, receives a plentiful harvest and a larger herd—repeating the agrarian symbolism of an ithyphallic god as guarantor of a bountiful harvest. Such symbolism was dominant, in those times, during the annual festival of Min. The recipient of the fruits of nature is, once again, the pharaoh.

Other texts speak of leading the calves to the tomb of Osiris to conceal his burial from his enemies. This ritual makes possible the association of the god of fertility with the resurrecting god of the dead, who was also sometimes depicted ithyphallically. The threshing of the grain by the calves would, therefore, have been an act that regenerated the vital forces of a "dead" nature, thereby making possible the resurrection of Osiris in the form of stalks of wheat. Yet another interpretation of this scene ascribes to it the function of politico-religious propaganda. The king, as the living Horus, would have had to inter his father Osiris—as had, in the past, both Horus and Min—at Heliopolis.

The body of the deceased harvest god took on the form of grain,

which was transferred to the earth by the calves treading on his body. By this means, the pharaoh would have carried out the function of the son of Isis, and, as such, would have had the right to reign over all of Egypt. Through its multilayered symbolism, this rite was incorporated into the ritual of many national festivals. Given its context, the driving of the calves likely accompanied a solemn coronation, confirmation, and jubilee as well as agrarian and perhaps even funerary rites. Whatever the religious significance of this ceremony, it served to legitimize the power of the pharaoh, incorporating him into the cult of fertility and bountiful harvests in the role of chief actor.

This association of a god with the reigning ruler frequently led to the identification of Min with Horus, the son of Osiris and prototype of the pharaohs. The two gods are linked in the following sequence of epithets: "Min, King of Upper Egypt, Horus, the Strong." In the course of further assimilations, Min was also associated with Harendotes (that is, with Horus, the avenger of his father), and with Harsiese (Horus, son of Isis). At times, Min is clearly viewed as the king of the gods. As the personification of sexual potency, Min was also ascribed the role of creator-god. According to one of the texts carved on the walls of the temple at Edfu, Min was the creator of the sky and the earth, of deities and people. Min also concerned himself with the continuity of the human race.

The sacred animal of Min was the bull, an animal symbolizing the sexual impulse. As was mentioned previously, a white bull participated in the ceremony of "Min's climbing up the steps." Texts dating from later times also refer to the "black cow of Min," whose precise role and connection with the white bull are not clear. One of the epithets for Min designates him as the "bull, who penetrates females, and creates the seed of gods and goddesses." A similar concept is found in the texts of the temple at Edfu, where Min is referred to as a "husband, who impregnates women with his member."

The chief centers of the cult of Min were Koptos and Akhmim, situated in Upper Egypt, as well as the Eastern Desert, which was inhabited by nomadic tribes. Written sources tell of the building of the temple at Koptos during the Sixth Dynasty, while mention of the abode of Min at Akhmim is found in written sources dating from the times of the New Kingdom. In both of these places, a dominant feature is a god-king,

whose mother and wife is Isis. Min was also worshipped at Memphis, Abydos, and Thebes, and during the Greco-Roman Period at Edfu and Dendera, as well as on Philae. Owing to his sexual and vegetative aspects, Min was associated with the Greek gods Priapus and Pan. The name of the latter god was the origin of the Greek name for Akhmim—Panopolis.

In Thebes, Min was associated with Amun-Re, who stood at the head of the local pantheon. Evidence of this association is provided by numerous sources dating from the New Kingdom and from later periods. The identification of the god of fertility with an ithyphallic incarnation of Amun, often called Kamutef, was particularly widespread. This god was represented identically to Min, and may therefore be regarded as a local variant of Min. The name Kamutef means "bull of his mother," which presents no difficulty in interpretation. We are dealing here with a sexual encounter with his own mother, indicated most distinctly in one of the versions of his name, in which the word "bull" is replaced with the designation "impregnator" (in Egyptian, *menmen*). Thus, what we have here is a specific type of autogenesis that appears to be completely illogical: The god couples with his own mother to create himself. The basic intent of this tale becomes clear in the context of the associated religious concepts. By repeating the act of creation, the god wished to stress the fact that there was no one before him. His unquenched, continually renewed potency had, above all, great significance for dynastic propaganda, which, during the period of the New Kingdom, represented every pharaoh as the child of an earthly queen and the god Amun-Re. Isis and Amaunet functioned most often as the mythological wives and mothers of Amun. The queen-mother, who played a similar role through her assimilation with these goddesses, not only ensured the divinity of the pharaoh as the fruit of a divine-human encounter but also provided the potential for the repetition of the creative act—and, therefore, of a kind of dynastic *perpetuum mobile*.

In later texts, a further step was taken toward eliminating the concept of paternity as a possible causative force preceding the autogenesis of the creator-god. In these texts, Kamutef is referred to as one who has sired his own father. Although the mother-wife remained decidedly in the shadow of Kamutef, this function was attributed, in some instances, to a

goddess who was readily promoted to the role of primeval deity—such as Hathor, at Dendera, who was designated the "divine mother of Kamutef." Egyptian concepts regarding Kamutef were an abstract creation of theological speculation; by no means do they provide satisfactory grounds for concluding that sexual relations between mother and son met with general acceptance in Egypt. Even Horus, the incarnation of nobility, had in his "biography" an incestuous episode; however, his rape of Isis was a punishment meted out to her, when she had once, unwittingly, brought shame upon him.

This took place at a time when the two rivals, Horus and Seth, had decided to test each other by turning themselves into hippopotamuses, and then remaining underwater for three months. The overly protective and provident Isis, who considered her child to be weaker than his rival, decided to save him from a vexing situation. She stuck a harpoon into the hippopotamus who was Horus, who at once emerged from the water; as a result, her son lost the duel. This proved highly embarrassing to Isis. This version appears in the text carved on a stele of the Second Intermediate Period (ca. 1785–1551 B.C.E.). According to other accounts, Horus at this time committed a significantly graver misdeed: In his anger, he cut off his mother's head. Her head was then replaced, by magic, with the head of a cow. For this reason, Isis is also frequently identified with the cow-goddess Hathor; in her anthropomorphic manifestations, the head of Isis is most often adorned with the horns of a cow. The imagination of Egyptian theologians often led them far beyond the bounds of daily life, although at times their tales bear comparison with the reports of the present-day gutter press. Isis, as indicated in the episode just described, may be considered the psychological archetype of the mother who harms her own children through her excessive zeal.

Other Phallic Cults

Greek authors write of the Egyptian god Kamefis, who is probably to be identified with Kamutef. One of these authors even refers to three forms of Kamefis, arising one from the other. The last in this sequence had the form of the sun.

Some of the characteristics of Kamutef were attributed by Egyptians of the pharaonic period to the god Iunmutef, whose name signifies "pillar of his mother," a possible reference to the pillar supporting the sky, which in turn is personified as a woman. Since the concept of the pillar was associated, in Egypt, with the concept of the bull, and its symbolism simultaneously bore a phallic implication, one might presume that Iunmutef was also considered to be the consort, or bull, of his mother—at times, perhaps only in the role of her supporter and helper.

Iunmutef was above all, the son-god, or divine son, and was therefore represented in art with the sidelock of hair that was characteristic of some young men. A similar attribute is found in the iconography of royal sons, while in the Greco-Roman Period, the sidelock is most often found in representations of the naked Horus-child, Harpokrates. As represented in numerous paintings and reliefs, Iunmutef always appears in the attire of the priest *sem*, leader of the ritual of many feasts—that is, wearing a panther skin across his chest. This important priestly function was often entrusted to the royal son, who, in such instances, was regarded as the living image of the son-god. On some occasions, in fact, the pharaoh himself, when assuming the role of head priest, had his chest embellished with a panther skin. More often, there appears in the attire of the ruler a similar symbol: an amulet in the form of a panther's head, affixed to his belt.

In addition to Min and Amun-Re (and Kamutef, as their incarnation), the group of ithyphallic gods also includes Osiris, who is represented as the reviving god of the dead, the guarantor of abundant vegetation and symbol of the return of nature to life. The mummified god was sometimes represented lying on a bed with his phallus erect. Isis was then depicted in the form of a falcon hovering over or sitting on his phallus. The result of their coupling was, as may be recalled, Horus, who was also represented in the form of this very bird. In some pictures, an ear of wheat is growing vertically up from the body of Osiris, in the same position as an erect phallus. By this means, the identification was made between fertility and bountiful harvests. As mentioned earlier, the natural or artificial phalluses of mummified male corpses were set in the same erect position. We will return later to the legend and cult of Osiris.

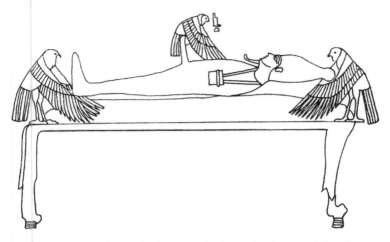

Coupling of Osiris with Isis, who has taken the form of a falcon. Relief in the temple of Seti I at Abydos.

Deities of the Earth and Sky: Wandering of the Sun

The father of Osiris, the earth god Geb, is also sometimes depicted in an ithyphallic manner. He appears as a man with a large, erect phallus in several versions of the classic scene in which the naked sky goddess Nut spreads her body out over the world, with her hands and feet resting on the earth. According to an ancient legend, this pair of deities procreated the sun, making Geb, in a sense, the primeval god. In early historical times Geb and Nut had already become associated with the Heliopolitan system of cosmogony, but only as the third generation of gods. A reminiscence of the primeval image is visible, however, in numerous scenes that represent Nut as a woman swallowing the sun in the evening, and from whose womb the sun reemerges in the morning. Large versions of this scene often adorned the ceilings of temples and royal tombs. Such images have survived to the present in, among other places, royal tombs dating from the Nineteenth and Twentieth Dynasties, as well as in the temple dedicated to the goddess Hathor, in Dendera, which was built during the Ptolemaic Period. In tombs of the New Kingdom, this scene

is a part of the *Book of the Day* and the *Book of the Night*. This scene illustrates the nocturnal journey of the solar disc within the body of the sky goddess, spread out on the ceiling. The text written on one of the papyri informs us that "the womb of the goddess is in the east, and her head is in the west," corresponding to the legend of the swallowing of the sun in the evening and its birth in the morning.

The concept of Nut daily giving birth to the sun is already present in the *Pyramid Texts* and is repeated in later works of religious literature concerning the afterworld. Rebirth, on the pattern of the sun, was the dream of the deceased. The deceased, expressing themselves through the

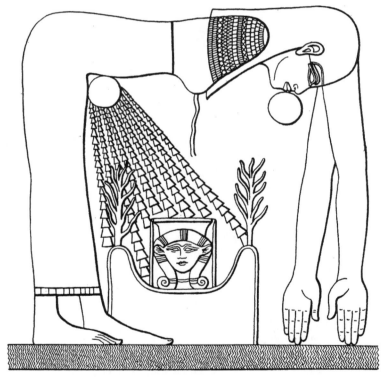

The sky goddess Nut swallowing the sun in the evening and giving birth to it in the morning. Relief in the temple of Hathor at Dendera, Ptolemaic-Roman Period.

thoughts and writings of the living, were readily identified with the children of Nut. Among these children was Osiris, a god with whom, from the times of the Middle Kingdom, every deceased person was identified. To ensure their resurrection, the deceased might, in the Egyptian notion, resort to the most brutal and devious methods. In one section of the *Pyramid Texts*, the deceased summons the sun god Re to impregnate the goddess Nut, thereby making possible his own entrance into her womb, together with the divine seed. Since Re was the child of Nut, there is a repetition here of the concept of the coupling of the son with his mother, known already as a characteristic of both Geb and Kamutef. Some texts inform us that, at the moment of sunset, Nut gave birth to the stars that glitter in the night, and therefore was regarded as the mother of all the heavenly bodies that provide light. She thereby ensured a *perpetuum mobile* of light. Iconographic sources show Nut as either naked or clad in a long gown that clings tightly to her body and is almost completely covered with stars. She is represented in this manner, for instance, on the lids of sarcophagi dating from the New Kingdom and later. There, she is represented as spreading out her body over the deceased—above the incarnation of her son Osiris. The texts accompanying these images often express the desire of the deceased to remain forever in the embrace, or within the body, of the goddess, particularly when the sarcophagus or tomb is described as Nut. In one text from the Roman Period, Nut is addressed as the mother and sarcophagus of the deceased: "Your [earthly] mother carried you for ten months. . . . I will carry you for an indeterminate time. I will never bear you."

Nut as mother played a significant role not only in mythological concepts but also in magic relating to matters of daily life. Identification with this goddess provided protection for the body of the child. In this case, the mother of the sun and the stars performed an apotropaic function. An original vision of the pregnant sky goddess bearing a youthful sun in her womb is found in a sketch on an ostracon dating from the New Kingdom—clearly, a preliminary sketch made by a skilled artist, prior to the sculpting or painting of a similar scene on the ceiling of a tomb. The sun has the shape of a disc, within which a child is sitting with its finger by its mouth. One of the scenes in the *Book of the Day* depicts the meeting of two celestial barks—representing, respectively, day and night—carrying

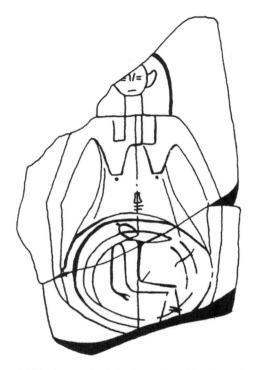

Solar disc with a child in the womb of the sky goddess. Sketch for the *Book of the Day*, drawn on an ostracon.

the sun god. On the prow of one of these barks stands a woman who personifies the East, while, on the prow of the other, there is an analogous personification of the West. One of the women passes over to the other a solar disc containing a figure of the sun god. In the morning meeting of the barks, this god has the form of a child, while, in an analogous meeting in the evening, the tired sun god is represented as an old man with the head of a ram, supporting himself with a cane. (Instead of an old man, sometimes a ram's head alone is depicted.)

The swallowing by Nut, in the evening, of her own child, the sun god, was sometimes associated with the image of a sow eating its own piglet. The swallowing of the sun by the darkness of night, identified with an

abyss in the body of the sky goddess, was not, however, intended to be appalling, since in the afterlife the sun remained in the embraces of Osiris, the god of the dead, and in any event was to be born anew.

One of the magical texts compares the parting of the spouses to the separation of Nut and Geb, or the sky and the earth. A cosmological scene depicting Geb and Nut is encountered particularly often in paintings on sarcophagi and in vignettes of papyri from the Twenty-first Dynasty and later times. An unconventional version of the creative act of Geb is preserved in one of the papyri currently in the British Museum. Here, the masturbating god has his body arched and is trying to direct his sperm toward his own mouth; standing above him is a male sky deity, resting on his palms and feet. This unique case was clearly not a jest on the part of its author, but rather an echoing of the Heliopolitan concept of the self-impregnation of a primeval god—relating, above all, to Atum.

Another reflection of the ancient notion of Geb as creator-god is his epithet "father of the gods," which appears in several texts. Most widespread was a later version of Heliopolitan theogony, which, however, places Geb only in the third generation, attributing to him an enhanced fertility, consisting in the procreation of two pairs of gods of exceptional importance in Egyptian religion. Osiris, Isis, Seth, and Nephthys quickly became national and popular deities, the protagonists of many myths. In one of the texts of the Late Period, the Metternich Stele, Isis is referred to as the "goose's egg"—the goose being the sacred animal of Geb.

Although Geb is represented in the iconography as a man from whose body sometimes water is spouting, or wheat and other plants are growing, these representations do not identify him as a fertility god but rather as a chthonic god. Geb was, above all, the earth god, and his name is associated, both in meaning and sound, with an Egyptian word for earth, *gbb*. Geb also played an important role in beliefs relating to the afterworld. The deceased wished to come out of the earth via the "gateway" of either the mouth or the jaws of Geb, and when Geb spoke, the earth, or its mouth, opened. Because Geb was regarded as the personification of the earth, he was the first of the earthly rulers, as indicated by inscriptions that describe the kingdom of the pharaohs, and which often contain allusions to the "throne of Geb" and his "heritage."

The cult of Geb was associated with the ritual of digging up the earth

with a hoe at Heliopolis—similar to what took place at Memphis in honor of the local chthonic deity Sokar. Wherever the color of paintings and reliefs representing this god is preserved, the body of Geb is green, which certainly emphasizes his vegetative aspect.

While Geb was invariably represented in anthropomorphic form, his female partner Nut also had zoomorphic incarnations. In addition to the previously mentioned image of the sow swallowing its young, like the sky goddess swallowing her stars (as she is sometimes represented doing, even in statuary, as in a faience figurine of the Late Period), Nut also assumed the form of the celestial cow, which was often identified with the goddess Hathor. We know of her primarily from the legend of the destruction of mankind by the sun god Re, which is recounted in the *Book of the Celestial Cow* that decorates the walls of the tombs of several of the pharaohs of the Nineteenth and Twentieth Dynasties in the Valley of the Kings at Thebes. The oldest known version of this text is written on the walls of one of the gilded shrines of Tutankhamen (Eighteenth Dynasty). This unusual creation of Egyptian theological thought possibly arose in conjunction with the heresy of the Amarna Period (i.e., the religious "reforms" of Amenhotep IV/Akhenaten). The *Book of the Celestial Cow* tells of the anger of the gods, who prompted the elderly Re to send out the solar eye (Hathor) against the rebellious people and then commanded it to kill a portion of the people. However, to protect the rest of the people from the destructive fury of the zealous envoy, the god made the goddess drunk with hastily brewed beer, and thereby cooled her fervor. But he also became disillusioned with the remaining portion of the human race and he resigned from the earthly kingdom. He retreated to the sky on the back of the celestial cow, from which he made decisions restoring order. He also activated several of the gods of the Heliopolitan Ennead, entrusting to them specific tasks: Shu was charged with holding up the sky, and Geb had snakes made available for his use, as befitted the earth god.

The Role of Sex in Egyptian Myths

An addition to the group of Egyptian fertility gods just discussed is Bebon, known primarily from the work of Plutarch concerning Isis and Osiris, and appearing in Egyptian texts under the name of Babaui. He

was regarded as the demon of sexual power and fertility. His characteristics had much in common with those of the violent, querulous Seth. It is, in fact, possible that Bebon was merely an avatar of Seth. The site of his cult was Herakleopolis, in Middle Egypt.

Not only ithyphallic gods but also their phalluses themselves were the objects of a cult. The Egyptians readily identified themselves with the divine phallus, primarily for magical purposes, to ensure their own sexual potency. The deceased were often referred to as the phallus of Re, Osiris, Min, or Bebon. There appear, in religious texts of the Middle and New Kingdoms, different versions of the threats aimed at gods by the deceased; blackmail was even employed to avoid dangers. Threats are made to swallow both the phallus of Re and the head of Osiris, and to destroy both Khepri and Atum, which would have brought about the end of the world. Re and Atum appear here in the role of creators, while Osiris and Khepri are the images of continual regeneration. Texts from the New Kingdom recount this legend in a modified form, in which the deceased does not swallow the head and the phallus, but instead, the phallus of the sun god swallows the head of Osiris.

The phallus of Osiris was held in particularly high esteem during the Late Period. Plutarch informs us that in the course of a festival reminiscent of the Dionysian phallophoria, a statue of Osiris—complete with a threefold, movable member—was carried in procession. Presumably, the Greek name for this festival (*pamyles*) was derived from the Egyptian designation for a priest or confessor of Osiris—"the Great of Love" (*pa-aa-merut*). Three different Egyptian towns had the phallus of Osiris attributed to them as a relic, while the fish that, according to other accounts, swallowed the member of this god, was regarded as sacred. The severed phalli of enemies were spectacular military trophies, symbolizing the complete disabling of an adversary. There is a representation, in relief, of a pile of such trophies on one of the walls of the temple of Ramesses III at Medinet Habu (western Thebes).

Votive figurines in the form of a phallus were in widespread use in Egypt as symbols of fertility. These objects were made of various materials—most often, of stone. One such votive object was found during the Polish excavations at Alexandria. A similar function was performed by several smaller sculptures, which represented a couple engaged in sexual

relations. The dominant element in these sculptures is the disproportion-
ately large size of the male member.

A natural consequence of the Heliopolitan version of theogony was
the concept of the androgyny of the creator-god. Atum, performing his
masturbatory act, which involved the creation of the first pair of gods
through the swallowing of his own sperm and giving birth through his
mouth, must have been considered a bisexual being. His female partner
was his own hand, and her vagina his own mouth. Consequently, the
name of this bisexual creator also had two forms, masculine and feminine.
The latter was obtained through adding to the name Atum the feminine
ending "t," yielding the name Atumet. During the Late Period, the fem-
inine form Atumet appears frequently in inscriptions engraved on the
sides of small bronze coffers that served as coffins for mummified eels and
lizards—sacred animals of Atum.

There were also other gods—in particular, primeval gods—who had
female variants that were named as described for Atum. Pairs of this type
include, for instance, Amun and Amaunet, found in Thebes from the
time of the New Kingdom. The precise function of the female element
in such cases is ambiguous. It is not always possible to determine whether
the female in question represents merely a female variant of the primeval
god or, instead, his female partner, daughter, or mother. Although the
latter role might appear to be an absurdity in relation to the creator of liv-
ing beings, divine and human, Egyptian theological thought did not ex-
clude such a possibility, particularly for purposes of propaganda.

Independent of the role ascribed to the different female variants, these
gods were associated, at different times and in various cult centers, with
the most diverse female partners as instruments of procreation. At
Thebes, Mut was worshipped primarily as the wife of Amun, and the
child of this pair was Khonsu, who is represented as a youth with the
sidelock of hair typical of both divine and royal children. Triads and
dyads of deities came to be characteristic features of the local pantheons
of the respective religious centers, where theology defined the familial
ties linking the major deities. This state of affairs was highly profitable for
dynastic propaganda, which frequently replaced one of the members of
the divine triad—most often, the divine child—with the currently reign-
ing pharaoh. This device enjoyed particular popularity during the reigns

of Ramesses II (Nineteenth Dynasty) and his successors. There survive many stone statues of this ruler, the majority colossal in size, representing the pharaoh in just such a context—for example, situated between the god Ptah and the goddess Sakhmet, who, together with their divine child Nefertum, comprised the Memphite triad. A statue representing the king in the place where Nefertum is expected to appear may have served to suggest the identity of Ramesses with the divine child of the couple, and thus to emphasize the divine nature of the pharaoh himself.

Gender differences are also indicated in Egyptian art through the use of color. In paintings, polychromatic reliefs, and sculptures, the skin of the man is red, while the skin of the woman is yellow. Even these rules have exceptions, however, which can shed light upon the relativistic Egyptian notions regarding the question of the sexes. Two hieroglyphic signs are often found side by side in polychrome inscriptions that have been sculpted or painted on the walls of tombs and temples. Both of these signs represent the head of a man, but in one case (the hieroglyph *her*) the head is shown from the front, while in the other (the hieroglyph *tep*) it appears in profile. When they appear side by side, these two symbols form a single semantic unit, meaning "the one who stands in front"—in other words, the "chief one." The most fundamental difference between these two symbols, however, lies not in the differing presentation of the head but in the coloration of the skin. In the surviving polychrome inscriptions, the head viewed *en face* has a yellow face, while the head shown in profile has a red face. Why, then, does a man's face sometimes have associated with it the male coloristic attribute and, at other times, the female attribute?

Some clues to this enigma can be found in two unusual representations of the deceased in a relief dating from the Ninth Dynasty (First Intermediate Period, ca. 2100 B.C.E.). This relief, sculpted on the so-called false door, comes from the tomb of a dignitary named Nefer-iu and is now in the Metropolitan Museum of New York. According to the principle of symmetry generally found in composition, in the "false doors" in the lower part of the relief there are two parallel yet contrasting representations of the deceased man. One representation depicts a young man with long hair and a slender, shapely silhouette, while the other is a likeness of an older, bald man, with a paunch and wrinkled skin. The skin of the

young man is red, while that of the older man is yellow. Most likely, these are not so much representations of the deceased at two different periods of his life as they are representations of two opposing aspects of his nature. The first is characterized by a youthful vigor, elasticity, and activity, sometimes expressed in an aggressive manner. The second, in contrast, is characterized by moderation and calmness, even passivity, which are traits generally associated with advanced age. The conviction that these two aspects of nature are present in every person arose from a dualistic conception of the world that was so characteristic of the mentality of the ancient Egyptians. In their view, every phenomenon, whether material or abstract, must have its antithesis, and harmony—an organic unity—could be achieved only through the fusion of these two elements.

Horus and Seth

The mythological personification of the contrasting aspects of human nature focused on the gods Horus and Seth, who were represented as inveterate enemies. The impulsive Seth, brother of Osiris, was the essential male, carried to the point of brutality. He caused great trouble but was not devoid of positive traits, such as valor, for which he gained the reputation of guardian and protector of the sun god. In sexual matters, he was the embodiment of the elemental male. Today, we would refer to him as macho. His polar opposite was Horus—the son of Osiris, who had been cunningly trapped and killed by Seth. Horus, although the incarnation of nobility, gravity, and common sense, as well as the avenger and successor of his father, was also somewhat of a sniveler. This interpretation of his character is derived from several literary versions of the myth of Osiris.

The contrast between these two gods is particularly clear on a sexual level, finding expression in their homosexual episode. As described in the *Pyramid Texts*, Seth raped Horus, directing his member between the buttocks and spurting his semen into Horus. In what may be the earliest literary reference to anal relations (dating from the second half of the third millennium B.C.E.), this was by no means an amorous act but rather a cunning form of revenge. The most complete version of this myth ap-

pears in the Chester Beatty Papyrus (No. 1), which dates from the reign of Ramesses V and is currently in the collection of the British Museum in London:

> The quarrelling deities came before the court of the Heliopolitan Ennead:
>
> Then the Ennead said: "Horus and Seth shall be summoned and judged!" So they were brought before the Ennead. The All-Lord spoke before the Great Ennead to Horus and Seth: "Go and heed what I tell you: Eat, drink, and leave us in peace! Stop quarreling here every day!"
>
> Then Seth said to Horus: "Come, let us have a feast day at my house." And Horus said to him: "I will. I will." Now when evening had come, a bed was prepared for them, and they lay down together. At night, Seth let his member become stiff and he inserted it between the thighs of Horus. And Horus placed his hands between his thighs and caught the semen of Seth. Then Horus went to his mother Isis: "Come, Isis my mother, come and see what Seth did to me." He opened his hand and let her see the semen of Seth. She cried out aloud, took her knife, cut off his hand and threw it in the water. Then she made a new hand for him. And she took a dab of sweet ointment and put it on the member of Horus. She made it become stiff, placed it over a pot, and he let his semen drop into it.
>
> In the morning Isis went with the semen of Horus to the garden of Seth and said to the gardener of Seth: "What plants does Seth eat here with you?" The gardener said to her: "The only plant Seth eats here with me is lettuce." Then Isis placed the semen of Horus on them. Seth came according to his daily custom and ate the lettuces which he usually ate. Thereupon he became pregnant with the semen of Horus.
>
> Then Seth went and said to Horus: "Come, let us go, that I may contend with you in the court." And Horus said to him: "I will, I will." So they went to the court together. They stood before the great Ennead, and they were told: "Speak!" Then Seth said: "Let the office of ruler be given to me, for as regards Horus who stands here, I have done a man's deed to him!" Then the Ennead cried out aloud, and they spat out before Horus. And Horus laughed at them; and Horus took an oath by the

god, saying: "What Seth has said is false. Let the semen of Seth be called, and let us see from where it will answer."

Thoth, lord of writing, true scribe of the Ennead, laid his hand on the arm of Horus and said: "Come out, semen of Seth!" And it answered him from the water in the midst of the marsh. Then Thoth laid his hand on the arm of Seth and said: "Come out, come out, semen of Horus!" And it said to him: "Where shall I come out?" Thoth said to it: "Come out of his ear." It said to him: "Should I come out of his ear, I who am a divine seed?" Then Thoth said to it: "Come out from the top of his head." Then it came out as a golden sun-disk on the head of Seth. Seth became very angry, and he stretched out his hand to seize the golden sun-disk. Thereupon Thoth took it away from him and placed it as a crown upon his (own) head. And the Ennead said: "Horus is right, Seth is wrong." Then Seth became very angry and cried out aloud because they had said: "Horus is right, Seth is wrong."[1]

The homosexual motif of the myth of Horus and Seth appears as early as the oldest known work of Egyptian literature, the so-called *Pyramid Texts*—hieroglyphic inscriptions found on the walls within the pyramids of the pharaohs dating from the end of the Old Kingdom (late Fifth and Sixth Dynasties, second half of the third millennium B.C.E.). The recently discovered fragments of text in the pyramid of Pepi I (Sixth Dynasty) tell explicitly of the seed of Seth between the buttocks of Horus; however, other parts of the text have led some scholars to conclude that the relationship was reciprocal.

It seems very likely that this myth gave rise to the Egyptian tradition, which has survived through the centuries, that presented Horus as an effeminate young man. Such an image was found, as noted earlier, in one of the Hellenistic terra cotta figurines discovered at Tell Atrib. Here, Horus is represented as the Horus-child (Harpokrates), in a provocative pose, with emphasis on the modeling of the buttocks and with one breast bared. It is appropriate to interpret this vision of a frivolous, effeminate youth as a specific *interpretatio Graeca* of an ancient Egyptian myth.

[1] From "The Contendings of Horus and Seth," Papyrus Chester Beatty I; M. Lichtheim, *Ancient Egyptian Literature: A Book of Readings*, Vol. 2 (Berkeley, 1976), pp. 219–220.

The contrasting natures of Horus and Seth, which are present in the nature of every person, became an important point of reference for Egyptian magic. This division was the basis for, among other things, the interpretation of dreams. The content of predictions arising during dreams depended upon whether the person concerned had the nature of Horus or of Seth. If an omen did not come to pass, it could be explained as a mistake in evaluating the nature of the person.

It may be fitting to see a similar symbolism in the pair of hieroglyphic symbols referred to earlier—*her* and *tep*. The first of these symbols, representing the face of a man with yellow (i.e., "womanly") skin, would have been associated with Horus, particularly since the phonetic value of the hieroglyph in question (*her*) was the same as the sound of the name of Horus in the Egyptian language. The sign *her* often depicts a face with a distinctly African cast to its features—thick lips; a wide, flat nose; and short, kinky hair. There may also be a reminiscence of those Egyptian myths in which Horus is the leader of a race brought from sub-Saharan Africa to the Nile valley. The yellow coloration of the skin can be seen as a logical consequence of the role played by Horus in the homosexual episode just described. Therefore, it also seems appropriate to associate the hieroglyph *tep* (which represents a rather long-haired man's head with red skin, in profile) with a personification of Seth, the other party in this conflict.

Regarding the coloristic and symbolic values of the hieroglyph *her*, the Egyptians covered the faces of the mummified deceased with a shroud in the shape and color of this sign, made of small faience beads strung on fine threads. As a reminiscence of Horus, this effigy of a yellow face on the face of the mummy symbolized the resurrection of Osiris (that is, of the deceased) in the form of his son. This symbolism could also have a magical meaning, enabling the regeneration of the deceased—his "coming out by day," the greatest dream of every deceased, expressed even in the Egyptian title of the *Book of the Dead*.

Homosexual Aspects of Myth

In Egyptian religious texts, homosexuality occurs sometimes as a condemned means of appeasing the sexual appetite. This is expressed most

clearly in the "negative confessions," a chapter of the *Book of the Dead* in which the deceased enumerate the sinful actions that they have *not* committed, including, for example: "I have not had relations with a man, nor practiced self-abuse in the sacred places of the god of my place." However, in the *Coffin Texts* (which pre-date the *Book of the Dead*), we are informed that: "Atum has no power over [the deceased] N, rather, N impregnates his buttocks." In this declaration, as in the *Pyramid Texts* and in later versions of the legend of Horus, relations between two men are viewed primarily as a demonstration of one man's superiority over the other, not as an act of love. For the passive, violated partner, having relations with another man was regarded as shameful or even disgraceful; however, the active partner was viewed as legitimizing his own masculinity through this act, and even taking pride in the act. For the passive partner, the embarrassing thing was not the homosexual act itself but rather the fact that the seed of another man entered his body. Only in this way was the passive partner considered to be deprived of his "masculinity"; the act of homosexual coitus itself seems to have been considered a morally neutral activity.

In homosexual relations, the sperm was considered a poison or venom, and thus the source of misfortune for the violated one (passive partner). All poisonous substances were designated in the Egyptian language by a similar word, *mtwt*, the meaning of which often remains ambiguous. Allusions to mythological homosexual rapes are also found in magic spells for protection against the bites of poisonous animals; for example, Seth's rape of the goddess Anat (who appears, in this exceptional case, in the form of a man) is the reference point in a spell against scorpion venom. Fear of the male seed in an incestuous relationship also appears in an ancient Memphite hymn to the god Nefertum, in which Shu and Tefnut fear the obscene pedophile spurtings of their father, Atum. "Do not let his seed enter into them," cautions the author of this text.

In the earliest phase of the development of Egyptian religion, homosexual relations may have been regarded as an act of transmission of sexual potency, fertility, and creative energy. An illustration of this concept may be seen in the "birth" of the moon from the god Seth. In a dream book contained in the Chester Beatty Papyrus (No. 3), sodomy appears as one of the unusual sexual practices, alongside having relations with one's

own mother or sister. Surprisingly, the only iconographic evidence of this is a series of obscene sketches executed by artists or artisans on the walls of several Theban tombs from the period of the New Kingdom. One of the literary texts refers to homosexual relations between the king Nefer-kare (Old Kingdom) and the general Sisenet as an example of corruption and demoralization.

Several texts suggest that homosexual practices were taboo, and were restricted to certain areas or temples. Other records, however, lead one to believe that such practices were tolerated, even respected, in certain circumstances. The "tomb of the two friends," which dates from the Fifth Dynasty (ca. 2360–2350 B.C.E.), and which was discovered only in 1964 and published only in 1977, is considered by some scholars as providing evidence that the willing cohabitation of two adult men was accepted—and even honored with a shared tomb. Ni-ankh-Khnum and Khnum-hotep, the two men who are thus entombed, were members of the innermost circle of the pharaoh. Both men bore the title, rare among royal courtiers, of "overseer of manicurists of the Great House," as well as titles such as "secret counselor," "confidant of the king," and various priestly titles. It may be assumed that these two men were primarily masters of the court in matters pertaining to manicure. Other scholars prefer to see in this couple simply a pair of friends and colleagues or brothers (twins).

It is, perhaps, appropriate to place in a similar context the fragments of the relief from Tell Atrib, referred to earlier and dating from the Ptolemaic Period, which represents two naked men standing side by side, the older one being distinguished by his gigantic phallus. Some elements in this iconography suggest, however, that the Greek god Dionysus is represented here with one of his companions, and that the scene should be considered an *interpretatio Egyptiaca* of a well-known Greek motif.

There is a great deal of uncertainty, in the subject at issue, associated with the period of the "heresy of Akhenaten" (Amenhotep IV/Akhenaten), which favored a naturalism reflected both in literature and also in the plastic arts. Breaking with the tradition, deeply rooted for more than a millennium, of representing the ruler in the conventional style, accentuating his male attributes, artists of this period represented the king as possessing an unambiguously feminine anatomy. His large thighs, broad

hips, frail chest, narrow shoulders, slender hands with delicate palms, elongated neck, and oblong face with delicate features all strongly suggest an effeminate man, who is subtle and sensitive. His likenesses, both in statuary and in bas-relief, do not differ greatly from those of his wife, the renowned beauty Queen Nefertiti. The iconography of this pair, as well as of the entire royal family (particularly in the later phases of the reign of the Akhenaten), clearly exhibits a caricatural tendency, particularly evident in the egg-shaped heads of the figures.

Independent of whether some researchers are correct in interpreting this phenomenon as a purposeful deformation of the skull, dictated by certain aesthetic preferences, it is appropriate to recognize the artistic conception of the ruler as symptomatic of a specific style. This particular style, which might be designated "expressionistic naturalism," probably relied on an overemphasis of particular features of the physiognomy. Without doubt, this unique likeness of an effeminate Akhenaten exhibits some features of a portrait, which in turn raises the question of why the body of this ruler is distinguished by certain female anatomical features. In similar fashion, a relief found on one of the stelae at Tell el-Amarna (the present-day name of the capital of the state founded by Akhenaten in Middle Egypt) represents an aged Amenhotep III—father of the "heretic" pharaoh—clad in female attire, with pendulous breasts reminiscent of the breasts of a woman. Although this matter has not yet been satisfactorily explained, there is substantial evidence to suggest the bisexuality of the rulers bearing the name of Amenhotep (III and IV), who reigned during the period of the decline of the Eighteenth Dynasty.

At the same time, the art of this period abounds in scenes that represent the family life of the royal couple—images full of tenderness and intimacy, showing the pharaoh, with his wife and daughters, in a manner not found either before or after in Egyptian art. We see Akhenaten and Nefertiti with their children on their knees, playing with them and kissing them. One of the bas-reliefs even depicts a "rendezvous in the garden"—a tête-à-tête of a young king and a queen, as she hands him a lotus blossom. The intimacy of this scene is also emphasized by the partners' anonymity, since there is no accompanying inscription.

All available evidence leads to the conclusion that, in matters of homosexuality, those acts that were condemned were regarded as morally rep-

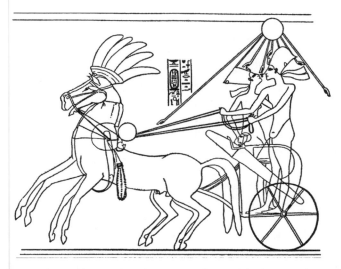

The "heretic" king Akhenaten kissing Queen Nefertiti while driving a chariot. Relief in the tomb of Ahmose at Tell el-Amarna.

rehensible: rape, casual contacts with "wags" (referred to by the term *hemti-tjay,* which may be translated roughly as "effeminate man"—perhaps a sort of male prostitute), sexual relations with young boys (pedophilia), and, worst of all, the fomenting of scandal and offense through sexual acts carried out in public. On the other hand, the cohabitation of adult males, with mutual consent, seems to have been regarded as morally neutral and was officially accepted. Although we have no direct evidence of homosexuality among women, several scholars investigating the *Book of the Dead* detect, in a chapter written for a deceased woman, evidence of lesbian practices. "I did not couple with a masculine woman [*tjayt hemut* = prostitute?]." The sentence spoken by the deceased woman in her "negative confession" may, however, be simply a calque of the formula that appears in an analogous text written for a deceased man.

In addition to homosexuality and incest, other types of unusual eroticism were known in Egypt. The mythological prototype of oral relations, associated with onanism, was Atum as the primeval god. In the work of Herodotus, the existence of necrophilia is also attested to, while certain

drawings on ostraca suggest the existence of zoophilia. *Coitus a tergo* (coupling from the rear) is illustrated, in various positions, in the Turin Papyrus, which is discussed in greater detail in chapter five.

The evidence of other iconographic sources suggests that the "from the rear" position was a favored one. Erotic scenes of this type occur, among other places, in reliefs decorating the surfaces of ceramic vessels dating from the second century B.C.E. found at Tell Atrib, made in the local workshops of ancient Athribis.

Substitutes for the female genitalia included not only the mouth and hand, but also the ear, nose, and eye. In poetic expressions, the vagina is sometimes referred to as the "door," or the "cave." These associations are found particularly often in love poetry.

The previously cited fragment of "negative confessions" from the *Book of the Dead* indicates that onanism, although reminiscent of the sexual urge exhibited by the primeval god, was not permitted everywhere, and the committing of such acts in temples was particularly blameworthy.

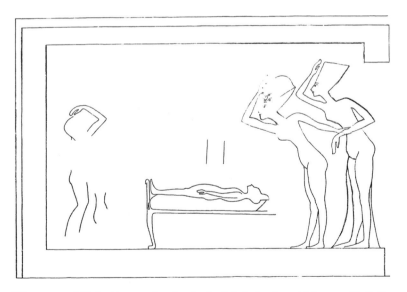

Akhenaten and Nefertiti mourning the death of their daughter, Meketaten. Relief in the tomb of the royal family, at Tell el-Amarna.

HERMOPOLIS AND THEBES

The dual sexual nature of the primeval god, or demiurge, which was embodied in Heliopolitan cosmogony in the figure of Atum, came to be expressed as a significantly more expanded theological concept in the Hermopolitan cosmogony. Here, the androgynous elements of the creator were divided among four pairs of gods, who assumed the forms of frogs and snakes. These deities are most often represented in human form, with the head of a frog (male deities) or of a snake (female deities). Each pair of gods consists of a male deity and a female deity, bearing similar names, who comprised the elements of the chaos in which the world was immersed prior to the appearance of the creator-god. Nu and Naunet were the incarnation of the primeval waters; Heh and Hehet personified spatial and temporal infinity; Keku and Kekuit represented darkness; and Tenemu and Tenemuit represented disappearance. Under the influence of Theban theology, Tenemu and Tenemuit were, in later times, replaced by Amun and Amaunet, who personified concealment. Some versions of Hermopolitan cosmogony place the eight primeval gods, often referred to by the Greek term *Ogdoad*, inside an egg, which floated in the primeval ocean. The creator-god emerged from the broken egg and created the world.

According to later (Ptolemaic era) accounts, the creator of the original octet of gods was, in primeval times, the sun god Shepsi, while the eight original gods procreated the sun god Re in the primeval waters. Other versions of this legend link the appearance of the cosmic egg with the ancestral bird, which must have been either a goose or an ibis. The ibis was regarded as the sacred animal of Thoth, the chief god of the Hermopolitan pantheon. Thoth is depicted most often in the form of an ibis, although he also took on the form of a baboon, particularly as the incarnation of the god of wisdom, the protector of scribes; the likeness of an ibis was also used in writing the name of Thoth. The Ogdoad is also associated with the ancient Egyptian name for Hermopolis—*Hmnw*, which signifies the "Town of the Eight Gods." The Greek name Hermopolis appeared only when Thoth began to be identified with the Greek god Hermes. One of the relics kept in this place was the shell of an ibis egg.

The cosmic egg was interpreted in various ways in the development of

Egyptian mythology, particularly regarding what hatched from it: According to some versions, this was a bird, identified as a falcon (the solar sky deity) or else as the goose (the so-called Great Gaggler) whose voice first broke the primeval silence. In other accounts, the egg hatches the sun (Re) or the air (Shu). In another legend, which apparently came into being under the influence of Heliopolitan cosmology, the sun god—that is, the primeval god—appeared in Hermopolis on the primeval mound (or on an island of fire) to overcome the primeval elements. These elements are identified with his enemies, who took on the form of bulls and cows destined for sacrificial offering. In a more pacifistic version, the incarnations of these elemental forces are baboons serving the sun god.

The process of creation of syncretistic theological systems led, probably as early as the time of the New Kingdom, to the assimilation of the eight original gods into the Theban system. The dominant role in this system was played by Amun, whose hypostasis was Kematef, a primeval serpent situated within the precincts of the temple at Medinet Habu. The dying Kematef ordered his son Irta (a name meaning "the one who made the earth") to create the octet of original gods. Only after its Theban birth would the Ogdoad have migrated to the north, to Hermopolis, to give birth to the sun god. This migration, however, did not complete either the wanderings or the creative activity of the Ogdoad. A further stage of the octet's wanderings embraced Memphis and Heliopolis, where they created, in succession, Ptah and Atum, the chief gods of the respective local pantheons. At the end of their wanderings, the octet returned to Thebes, where they were buried in the temple of their forefather, Kematef. Medinet Habu was the site of their posthumous cult. In this way, the Theban system, in the process of developing the genealogy of the gods, carried out a total theological synthesis in which the primeval gods of other major systems were subordinated to the great god Amun, who functioned as the state deity.

Khnum, Creator of the Human Race

Yet another important creator-god was Khnum, who was worshipped particularly in the southern parts of Egypt. Khnum appears in the form of a ram, or a man with a ram's head. He stood at the head of the local pan-

theons of several regions and personified various aspects of fertility. In the region of the First Cataract of the Nile (particularly at Elephantine), Khnum was worshipped as the god responsible for the annual flooding of the Nile, with Elephantine considered the source of cold, fresh water. At Elephantine, Khnum was referred to as the Lord of the Cataract; Khnum, together with the goddesses Satet and Anuket, comprised the local triad of deities. The creator of the floods was naturally also considered the lord of abundant harvests, and was therefore regarded as the guarantor of fertility. In this character, Khnum was associated with the crocodile Sobek, god of the waters and fertility, who was worshipped especially at the oasis of Fayum and was sometimes considered to be the primeval god, the creator-god, and the great benefactor.

The life-giving Nile was also personified in the form of an obese man with a large paunch and with pendulous, sac-like breasts, clad only in a band that covered his genitals—as if to avoid being identified with a specific sex. Images of this god played an important role in propaganda and therefore appear frequently in the reliefs of Egyptian temples. These im-

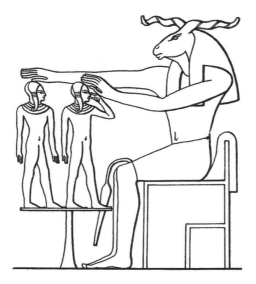

Khnum creating a royal child and his *ka* on a potter's wheel. Relief in the temple of Amenhotep III at Luxor.

ages symbolized abundant harvests, whose guarantor was the pharaoh. On temple walls, whole processions of anthropomorphized Niles bear various gifts of nature. The head of each figure is adorned with the emblem of one of the districts of Upper or Lower Egypt, characterizing this figure as the personification of a specific district. Among the offerings, there often appears the royal cartouche with the royal name, suggesting that the source of this abundance, on the same level as the Nile, is the pharaoh. Equally direct in its propagandistic goal is a scene that often decorates either the royal throne or the base of the throne: a symbolic motif of the unification of both parts of the country, with two personified Niles binding together the respective heraldic plants of Upper Egypt and Lower Egypt. Clusters of similar plants adorn the heads of both figures, and the name of the king dominates over the unification symbol. The overall effect conveyed here is that, with the aid of the Nile, the pharaoh rules over a unified realm, ensuring good harvests and general abundance.

In the Upper Egyptian locality of Esna, Khnum was regarded as the creator of people, whom he shaped on his potter's wheel. Numerous hymns and other religious texts dedicated to the "potter-god," who is represented repeatedly at his work, are carved on the walls of the temple at Esna, built during the Roman Period. These inscriptions and pictures enhance the image of the god as creator and guarantor of good harvests from a sexual standpoint, comparing him to a lusty bull of unusual sexual potency. The partner of Khnum in the Latopolitan pantheon (Latopolis

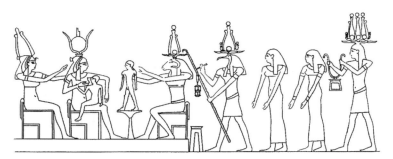

Divine child formed by Khnum and suckled by Isis. Relief in the *mammisi* at Philae, Roman Period.

was the Greek name for Esna) was Menhit, a goddess identified with the goddess Neith, who was worshipped in Sais, and with Tefnut. Their son was the god Hekau. The Khnum-Menhit-Hekau triad was identified with the Heliopolitan deities Shu, Tefnut, and Geb. In another location of the cult of Khnum—Antinoe, in Middle Egypt—the ram-headed god was associated with the frog-headed Heket, who fulfilled, among other functions, that of midwife at the divine birth of the king. As her partner, Khnum also took on the role of male midwife.

Khnum's creation of people on his potter's wheel is another notion that was popular in Egypt regarding the generation of the human race through the will of a god. As noted earlier, in the Heliopolitan system, human beings were considered to have been created by the divine eye, emerging from its tears. This concept is most likely the source of the similarity between the ancient Egyptian words for "person" (*rmt*) and "tears" (*rmyt*). Several scholars consider this to be an intentional play on words.

MEMPHIS

The most abstract cosmogonic concept arose in Memphis, the capital of the country during the Old Kingdom, situated at the boundary of Upper and Lower Egypt near Heliopolis. It is not known precisely when this system was created, since its only known record is a document of relatively late date: a text carved on a granite stele during the reign of Shabaka (Twenty-fifth Dynasty, end of the eighth century B.C.E.). The stele, which was discovered in Memphis, was originally located in the temple of Ptah. The poor condition of the text provides clear evidence that, in later times, the granite slab was used as a millstone. This document is, without doubt, a copy of an earlier text, written on papyrus; its archetype probably dates from the end of the Old Kingdom.

The portion of the text which is of interest here comprises a treatise that deals with the essence and significance of the god Ptah. This primeval god created the universe through the force of his reason and his power of speech. The seat of reason is the heart of this god, and Sia is the personification of this creative force. The utterances of the divine mouth are personified by Hu, who formed a divine pair with Sia. Acting with his will through reason and speech, Ptah created Atum and his Ennead.

Thus, the Heliopolitan pantheon became subordinated to the Memphite demiurge, and the purely biological creative element, in the form of masturbation by the primeval god, was replaced here by intellectual and psychological elements. The concepts of Hu and Sia diffused into Egyptian religion, as reason and speech also began to be attributed to various local creator-gods such as Thoth, Hapy (who personified the Nile), and even the king, as the earthly regent of the primeval god.

In spite of such an intellectual system of cosmogony, Memphite theology over time (at the latest, at the time of the New Kingdom) came to ascribe to Ptah a female partner who had the form of the lion-headed, mighty, menacing goddess Sakhmet. These two deities, together with a younger god, Nefertum (whose name, in Egyptian, signifies "Atum is good"), formed a triad. Nefertum is depicted with a lotus flower on his head. Other goddesses popular in the region of Memphis were also associated with the role of Ptah's wife. These goddesses included, among others, Ishtar, the Babylonian-Assyrian goddess of love, fertility, and war. Like Sakhmet, this Asiatic war-goddess had magical healing properties attributed to her, and prayers were addressed to her for aid in healing diseases. Such a request is expressed, among other places, on a unique votive stele dating from the reign of Amenhotep III, which represents an Egyptian man with one leg deformed by infantile paralysis and his wife in the act of bestowing abundant gifts on the goddess Ishtar, to whom the text of the stele is directed. Amenhotep III, having in his harem a princess from the Asiatic kingdom of Mittani, also received, in the thirty-sixth year of his reign (shortly before his death), a figurine from Nineveh representing Ishtar—a gift from his father-in-law, King Tushratta of Mittani. If the figurine was sent for medicinal purposes, it was probably not very efficacious.

Worshipped particularly, although not exclusively, in Memphis, and often regarded as being two forms of the same deity, the Semitic goddesses Astarte and Anat were designated as partners of Seth. In one papyrus they are referred to as the daughters of Re and the companions of Seth; another informs us that both goddesses were pregnant but did not give birth.

Toward the end of the Ptolemaic Period there developed in Memphis an eclectic version of cosmogony in which there was a merger of all four

major theological systems—those of Heliopolis, Memphis, Hermopolis, and Thebes. In this version, Ptah first emerged from the primeval ocean, in the form of the primeval mound (*Ptah Tatenen*), to create four pairs of gods in the likenesses of cows and bulls. The bulls procreated the black bull Amun, while the cows gave birth to the black cow Amaunet. Amun and Amaunet then mated, and the seed of Amun fell into a pond in Hermopolis, from which grew a lotus flower bearing a scarab with the head of a ram. As a result, the sun appeared and lit up the darkness. In the course of its wandering across the sky, the sun-scarab changed its shape every hour. In the first phase of the sky's *perpetuum mobile*, the sun-scarab transformed itself into an infant with a finger at his mouth, bearing the insignia of royal power in the form of a crown on his head and a uraeus on his forehead. Concepts of this type were reflected in cults and rituals, as well as in Egyptian art.

Figurines representing a young, naked god with the double crown of the pharaohs on his head, sitting on a lotus flower, have been found, among other places, in Ptolemaic Athribis. The iconographic variety of other figurines representing this god singles him out from the remaining deities of the Hellenistic pantheon. Consider, for instance, the images of Harpokrates galloping on a horse, riding on various other animals (e.g., an elephant), and sitting on the throne wearing an Egyptian crown and Greek garb. Many depictions of Harpokrates by the coroplasts of Hellenistic Egypt have a phallic character, though several terra cottas represent him with effeminate features, perhaps echoing the homosexual episode found in the myth of Horus and Seth.

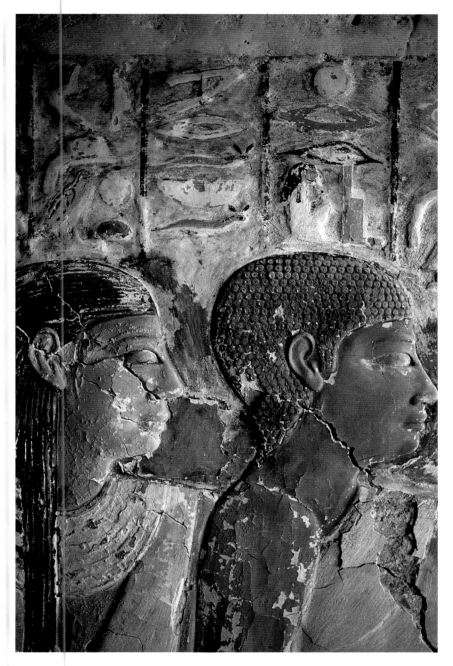

Family portrait: Vizier Meref-nebef and his wife, Sesh-seshet. Polychrome relief at the entrance to the tomb of the vizier at Saqqara, Sixth Dynasty (ca. 2300 B.C.E.).

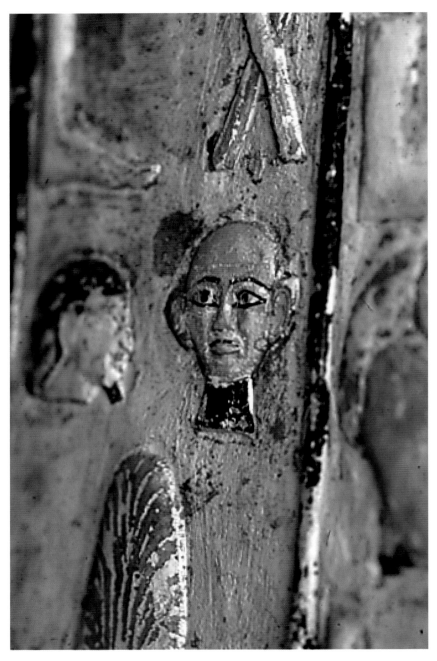

Hieroglyphic sign *her* in an inscription on the wall of the tomb of Meref-nebef. Next to this hieroglyph is the sign *tep:* a man's head with red-colored skin (not preserved).

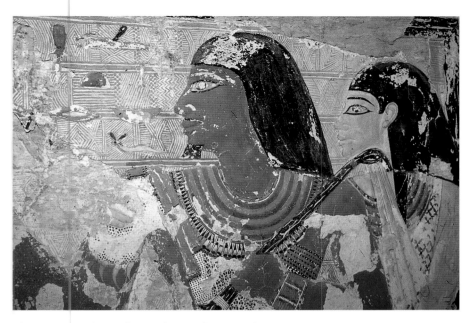

The vizier and his wife watching a dance performance.

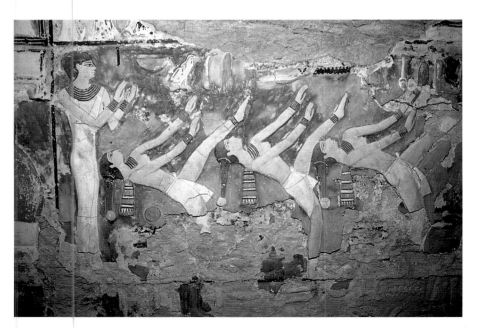

Acrobatic dance performed before the vizier.

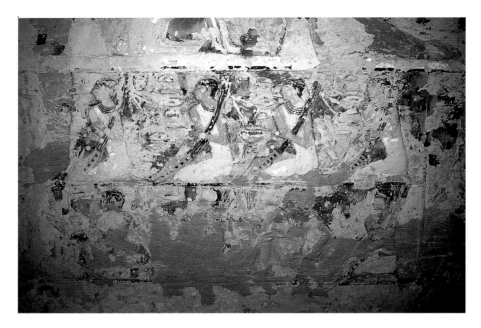

Quartet of harpists—spouses of the vizier—accompanying the dance.

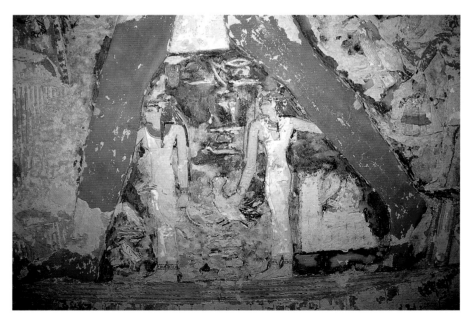

Two spouses of the vizier accompany Meref-nebef at a hunt; the disproportionate size of the figures follows a basic principle of Egyptian art.

Figurines of women from the public baths at Tell Atrib (the ancient Athribis) in the Nile Delta. Terra cotta, Ptolemaic Period, 3rd-2nd centuries B.C.E.

Isis-Aphrodite *anasyromene* (with uncovered pubic area).

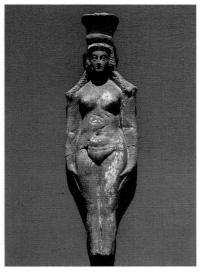

"Concubine" with a basket on her head.

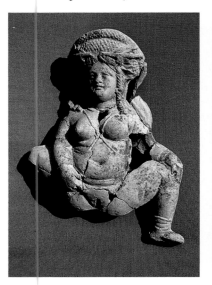

"Pseudo-Baubo": squatting naked pregnant woman.

Isis with two sons—probably identified with Cleopatra I.

Phallic-shaped votive figurines from Athribis. Terra cotta, 3rd–2nd centuries B.C.E.

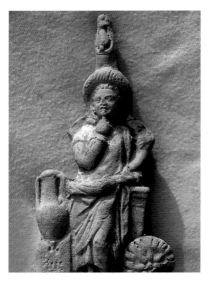

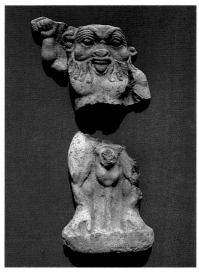

The Horus-child (Harpokrates) with an Egyptian crown on his head, dressed in a Greek cloak.

Bes with a magic instrument (snake and sword) in his hands (not preserved).

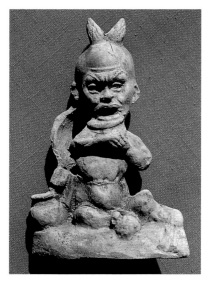

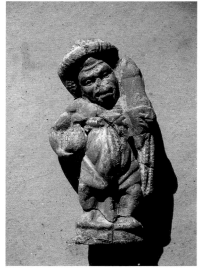

Drinking god with lotus clusters on his head.

Grotesque figure of a servant.

Votive figurines from Ptolemaic Athribis. Terra cotta, 3rd century B.C.E.

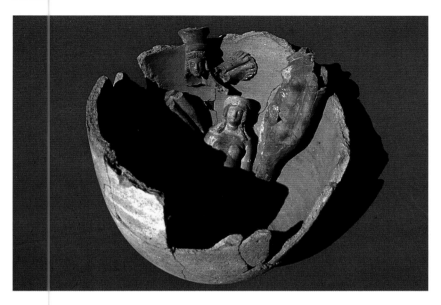

"Concubine" set in a clay vessel, from the flooring of the baths.

Woman giving birth in squatting position. Torso not preserved.

Erotic scenes in relief decorating ritual vessels. Tell Atrib, 3rd–2nd centuries B.C.E.

Couple in bed. Clay vessel appliqué.

Fragment of love scene. Faience vessel appliqué.

Coitus a tergo. Fragment of a rhyton decoration.

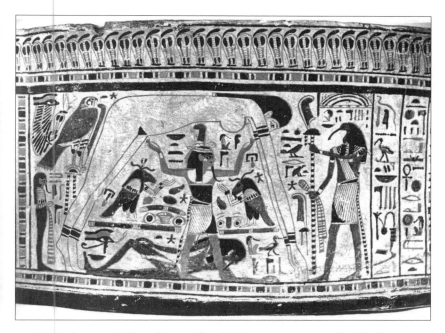

Mythological scene with Nut, Geb, and Shu. Painting on a wooden coffin, Third Intermediate Period.

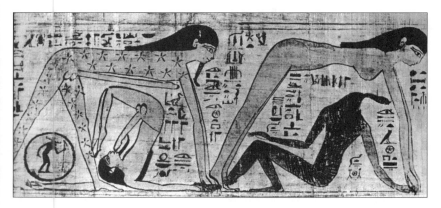

Geb as an ithyphallic primordial god. Painting on papyrus, Third Intermediate Period.

The ithyphallic god Amun-Re with the pharaoh. Reliefs from the temples at Karnak.

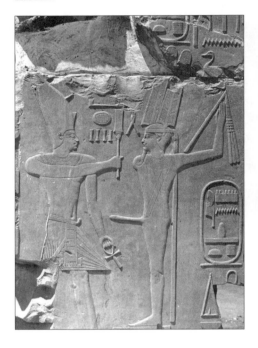

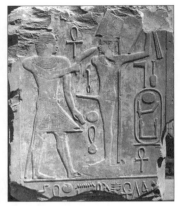

Amenhotep I offering lettuce to the god.

Amenhotep I presenting a scepter to the god.

Hatshepsut in ritual run with vases before the god.

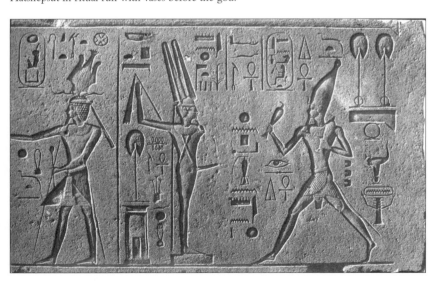

Phallic Greek gods in the Egyptian version. Fragments of terra cotta figurines from the Ptolemaic Period, from the excavations at Tell Atrib.

Dionysus holding up his gigantic phallus while leaning on a small Pan.

A hairy Pan in the company of a young man wearing a tunic.

Lower section of a phallic figurine.

Erotic aspects of Harpokrates. Terra cotta figurines of the Ptolemaic Period, from the excavations at Tell Atrib.

Young god with two phalluses (right).

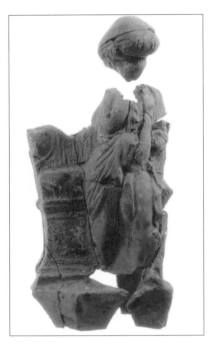

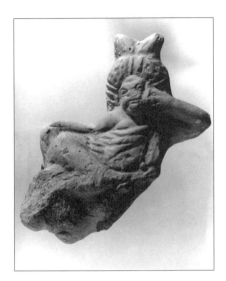

An effeminate Harpokrates, front (above) and back (below).

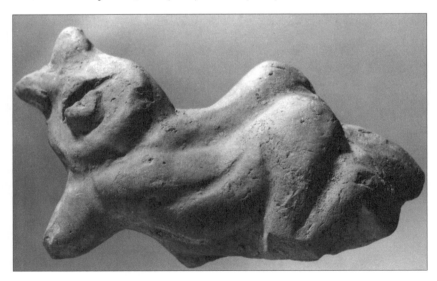

Terra cotta figurine of an elephant, with scenes molded in relief

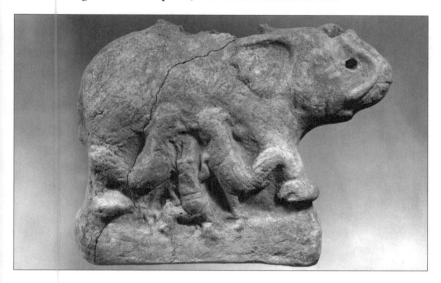

Bes dancing between two roosters.

Pair of megalophallic dancers.

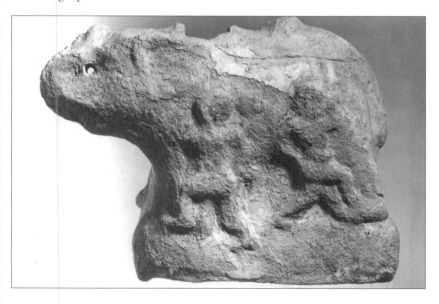

Fragment of a vessel with a representation of hands squeezing breasts. Middle Kingdom.

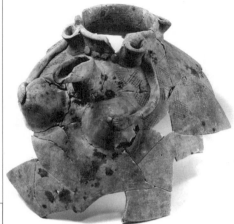

Small terra cotta oil lamp showing two children in the mother's womb. Byzantine Period, from the excavations at Tell Atrib.

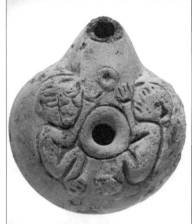

Vessel decorated with the head of Bes. Late Period.

Young king and child god

Harpokrates (Horus–child).
Terra cotta figurine from the excavations at Tell Atrib.

Ramesses II with the sidelock of youth. Relief on a stele.

Erotic figurines sculpted in stone

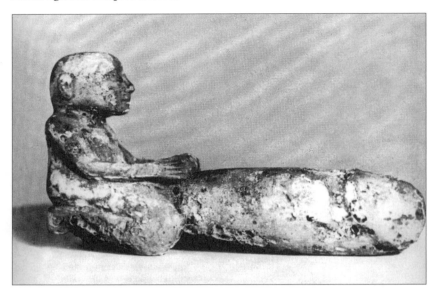

Megalophallic man.

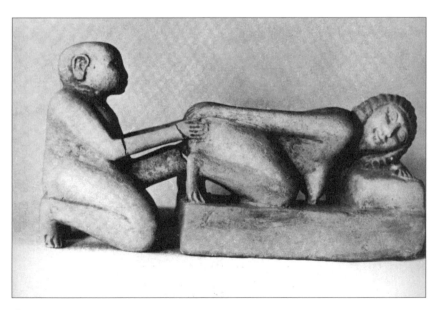

Coitus a tergo.

2

Osiris in Myth and Cult

Just as Atum and the other primeval gods ensured the creation of the world, the guarantor of regeneration and therefore of cyclically repeating procreation was Osiris. He continued the work of the creator-god. The myth of Osiris was particularly popular in Egypt, and Egyptian literature has passed on various versions of the myth. In a unique way, the cult of this god united various aspects of fertility; it was the quintessence of ancient Egyptian concepts regarding the life of a human being as a microcosm of the entire natural world. Legends relating to Osiris not only constituted a part of the official religion but were also widely dispersed among the Egyptian people, as they were linked with agrarian cults. Above all, every Egyptian saw in Osiris his or her own posthumous incarnation, and found hope of resurrection in the curriculum vitae of this god. In addition to the numerous surviving Egyptian accounts, an important source of knowledge concerning the legend of Osiris is the work of Plutarch (first century C.E.) entitled *De Iside et Osiride*, a type of moral outlook painted on the canvas of Egyptian religion. Its basis is the opposition between the noble nature of Osiris and the evil character of Seth. This work contains a wealth of interesting detail concerning both the beliefs of the Egyptians and also their religious festivals and rituals.

Osiris was the son of the deities personifying the sky and the earth. From his father Geb, the earth god, Osiris received dominion over the

earth, and was therefore considered ruler of all of Egypt. Because of this title, he is frequently identified with the pharaoh. The era of the reign of Osiris and Isis, his wife and sister, was considered to be a "golden age" in human history. Osiris taught the people agriculture and civilized them, while Isis established the institution of marriage. This idyll was cut short by a crime committed by Seth, the younger brother and rival of Osiris. Seth envied the knowledge and influence of Osiris, and during a feast shut his brother into a wooden chest, which he then cast into the Nile. According to some accounts, Osiris was drowned; according to others, Seth cut Osiris's body into pieces, which later became relics in the various centers of the cult of Osiris. Each part of the body was believed to have been buried in a different place, and the tomb of each of the divine body parts was incorporated into a temple. Yet another version of the death of Osiris is found in the *Coffin Texts*: To kill his brother, Seth transformed himself into a venomous creature living in the water. He then burrowed under the sandal of Osiris and cut a duct in his foot, by which he reached the blood and poisoned Osiris.

The goddesses Isis and Nephthys searched desperately for the corpse of their brother, with the aid of Anubis—who, in the Greek version of the myth, is the son of Osiris and Nephthys, the fruit of an accidental impregnation that took place when Osiris had trouble distinguishing between two similar sisters. The child of this unlawful union was abandoned by his mother, who feared the anger of her husband Seth, and then taken under the care of Isis. This episode should probably be regarded as a Greek interpretation of the Egyptian myth, in which Nephthys—the antithesis of Isis—was considered a barren woman. In the Egyptian creeds, Anubis was the god responsible for the mummification of corpses and is depicted with the head of a jackal.

According to the version of the myth recorded by Plutarch, the chest containing the body of Osiris was found in the vicinity of Byblos, on the coast of Phoenicia. Seth stole the body of his brother and cut it into pieces, which he then spread all over Egypt. Isis gathered the scattered parts of Osiris's body and mummified them with the assistance of Anubis. The only part missing was the phallus, which had been swallowed by a fish, so an artificial phallus was attached to the mummy, restoring to Osiris his potency and fertility. The coupling that then took place be-

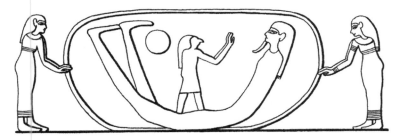

Birth of Horus from the body of Osiris. Relief in the tomb of Ramesses VI in the Valley of the Kings.

Harpokrates, the Hellenistic version of the Horus-child. Relief decorating a ritual vessel of the Ptolemaic Period, from the excavations at Tell Atrib.

tween Osiris and Isis is depicted on the walls of temples and coffins. The ithyphallic mummy of Osiris coupled with the goddess, who had assumed the form of a falcon and sat on the phallus of the god.

In spite of the fact that these scenes suggest a type of *coitus posthumus*, we cannot be certain that Isis did not become pregnant while Osiris was still alive. In any event, the pair of deities had progeny. Their child was Horus, known as Harpokrates during the Greco-Roman Period. This Greek name is merely a Hellenized version of the Egyptian designation "Horus the child." Horus is frequently depicted as a royal child with a finger at his mouth, naked or clothed in Egyptian or Greek attire, and often wearing various Egyptian crowns on his head. As noted in chapter 1, one of the features associated with the iconography of Horus was a lock or tuft of hair hanging down from one side of his head—a characteristic feature of princes and young gods. Sometimes, Harpokrates is represented sitting on a lotus flower, emphasizing his solar aspect. Figurines of this god, made most often of clay or bronze, have been found practically everywhere in Egypt, a testimony to his immense popularity during the Greco-Roman Period. They are most frequently votive figurines, which play an important magical role. The apotropaic function of the Horus-child is attested to by numerous stelae dating from the Late Period and the Hellenistic Period. They depict a child standing on crocodiles and holding in his hands various venomous animals; the accompanying inscriptions are primarily magic spells against the threat of these animals. This iconography is linked with a certain dramatic episode in the life of the divine child. During a brief absence by Isis, Horus was bitten by a scorpion or a poisonous snake and began to lose consciousness. His desperate mother applied to the sun god Re for assistance, and Re sent to the rescue the god of wisdom, Thoth. As a result of Thoth's intervention, Horus regained his health and became immune to the venom of snakes and scorpions. This property promoted him to the role of a magical intercessor.

Stelae of the "Horus standing on crocodiles" type are crowned, as a rule, by the head of Bes, a beneficent god and protector of women in childbirth. Bes is distinguished by his dwarfish posture, fringed beard, and long phallus (which, however, is never represented in an erect state). As a magical symbol, the face of Bes, in bas-relief or painted, frequently adorns large clay jars that were used to hold the milk of nursing mothers or wet nurses.

In the Hellenistic Period, there was a marked increase in the importance of Bes, this ancient god of caricatural appearance. Bes was recognized as the partner of the Greek goddess Aphrodite and was often represented in the form of a dancing jester. Many carved stone likenesses of Bes survive at Dendera, in the temple dedicated to the goddess Hathor, the Egyptian counterpart of Aphrodite. In Ptolemaic Alexandria, statues of this god, and other objects having the shape of Bes (for instance, a gold rhyton), decorated the temple of Aphrodite. The goddess Aphrodite was identified with Arsinoe Philadelphos, the wife of Ptolemy II (third century B.C.E.). Evidence of the immense importance of Bes during this period has also been uncovered in the area of Saqqara, the necropolis of ancient Memphis. Along the walls of a large cult edifice were clay statues of Bes, of imposing dimensions, with a lavish polychrome coating. A small limestone altar with a likeness of Bes in relief was found in one of the artisan's workshops of ancient Athribis, near fragments of beautiful marble sculptures representing Aphrodite. Numerous terra cotta figurines of Bes, showing him holding the instruments of his magic power—his sword and snake—in his hands, were unearthed in the nearby public baths, accompanied by many other figurines of an erotic nature. All of the structures just described were associated with various aspects of the cult of fertility.

Another popular iconographic motif derived from the legend of Osiris is that of Isis holding Harpokrates on her knees and breastfeeding him. Votive figurines of this type, which are found as often as those representing the Horus-child, were considered important magical instruments and accompanied requests for fertility made to Isis. The form of these figurines also appears in early Christian art, in which the motif of the Egyptian goddess-mother is transformed into a representation of the Madonna and the Christ Child.

One of the other aspects of the legend of Osiris is the act of Horus avenging his father. This conflict developed into a long battle that Horus waged with his uncle Seth—who, in his dealings with Horus, acted with equal amounts of sly cunning and brutality, as he had with Horus's father. In this latter struggle, Horus nearly lost one of his eyes when it was wounded by Seth, but he was subsequently cured by Thoth. Owing to this act of miraculous healing, magical powers were attributed to the eye (*udjat*), and eye-shaped amulets became extremely popular. According to

several scholars, the temporary loss of an eye by Horus had a symbolic significance and is fittingly linked with a loss of manhood in the homosexual episode referred to in chapter 1.

Owing to the efforts of his wife, Osiris returned to life; however, he ceded to Horus his rule of the world of the living and contented himself with being king of the underworld. The resurrected god and his son personified victory in the struggle with evil, the return of the dead to life, the regeneration of nature, and the indestructibility of all vital forces. Subsequent episodes of the legend were identified with successive and cyclically repeating phases of the course of nature. Every year, in the last month of the season of floods, a miracle play reenacted the death and resurrection of Osiris. Although the precise nature of these rituals remains unknown, it is likely that during the Greco-Roman Period they were similar to the Eleusian mysteries—rites of an agrarian nature that were celebrated in Greece to worship the goddess Demeter. The festivities in honor of Osiris lasted for two weeks and consisted of episodes reminiscent of the rites and ceremonies observed by Christians during Holy Week.

One of the most important ceremonies was carried out at night, on a sacred lake, where a procession of barks, or papyrus boats, bore statues of various deities. One of these barks bore the mummy of Osiris, which was then deposited in his tomb—a process that was referred to as the "navigation of Osiris" and was carried out by lamplight. At the tomb, liturgical texts were recited that recalled, for instance, the laments of Isis and Nephthys. The culminating moment of the festival was the celebratory resurrection of the god. Statues of deities were carried in joyous procession, songs were sung, litanies recited, incense burned, and offerings made, all with musical accompaniment. The king—or his emissary, who was selected from among the most exalted of the priests—participated in the procession. The procession made its way around the sacred precinct and then visited the tomb and the cult chapel of Osiris. The resurrected god was returned in triumph to the temple.

The fertility of Osiris, in both its sexual and agrarian aspects, was emphasized by grain effigies of Osiris (the so-called sprouting Osiris) that were prepared for this very festival. These figures were made of clay mixed with grain and were then watered for several days. When the barley had sprouted, the figures were exhibited in public. Also known are

molds in the shape of Osiris, which were filled with soil and grain, for the demonstration of a similar regeneration. The molded figures were prepared for the ceremonies that preceded the burial; they were then covered with a linen cloth that imitated a mummy and watered for eight days. As sprouts appeared on the surface of the cloth, they were interpreted as irrefutable evidence that Osiris was alive; given this evidence, the deceased must have undergone a similar resurrection. The chthonic and vegetative aspects of Osiris were also emphasized by the green or black color of his skin.

Although the mysteries of Osiris were performed at all the centers of his cult, the central festivities took place at Abydos, a locality in Upper Egypt where, it was believed, the head of the god of the dead was buried. From time immemorial, Abydos had been the destination for pilgrimages of the faithful; it was also the site of the necropolis of many pharaohs of the first two dynasties. Since the possession of a tomb at Abydos was considered to be a great honor, the most important and wealthy dignitaries who had their tombs in other places erected cenotaphs (mock tombs) at Abydos, or at least at the site of a cult, in the form of a stele with an offering formula.

In Lower Egypt, the most important center of the cult of Osiris was Busiris (a Greek adaptation of the Egyptian name *Pr-Wsr* = "house of Osiris"). The rites celebrated here in honor of Osiris emphasized the role of the goddess Nut as his mother. Nut had the symbolic form of a sycamore—the tree into which was laid, and subsequently buried, a figure of Osiris, made of earth mixed with grain. The effect was similar to that in the case of other variants of the "sprouting Osiris." The earliest known evidence of rites of this type, with vegetative-regenerative symbolism, is burials of the predynastic cultures of Merimde Beni Salame (southwest Delta region), where the mortal remains were strewn with grain. However, we are unable to verify whether this custom was actually one of the first forms of the cult of Osiris, since his name first appears only during the Fifth Dynasty.

Specific forms of the cult of Osiris were developed at Athribis, the Lower Egyptian locality where—as was well known—the heart of Osiris was buried. The protector of this relic was the goddess Khuit, designated as "she who clothed [wrapped with bandages] the god." Also worshipped here were

other deities of the Osiris circle, above all Horus, whose local variant bore the name of Khenti-kheti, as well as Isis and Hathor. In the Ptolemaic and Roman periods, these goddesses are identified with the Greek goddess Aphrodite. Numerous statues of Aphrodite made from imported marble were recently unearthed by the Polish archaeological team carrying out work at Athribis. One of the zoomorphic forms of Horus Khenti-kheti was Kemwer ("great black bull"), the subsequent local version of the pan-Egyptian symbol of fertility, sexual potency, and all vital forces.

The Polish-Egyptian archaeological team conducting excavations at Tell Atrib (Athribis) recently unearthed a structure housing a bath, whose function was undoubtedly associated with the cult of fertility. The bath consisted of chambers containing small basins of various shapes, among which occur many ovoid double basins with seats at the back and water outflow in the front. Each of these basins was designed for use by one person. A terra cotta figurine found in the vicinity of the baths represents a naked woman sitting, with widely spread legs, on just such a basin, rinsing herself with water with the aid of a bowl. The modeling of her body suggests that the woman is pregnant. Similarly prominent bellies characterize other figurines of naked women found at the same site. One of these figurines, in a better state of preservation, represents a woman in a similar position, stretching her hand toward her pubic region. Her attire consists exclusively of shoes, large decorative chains that cross between her breasts, a necklace, and a lavish headdress consisting of a floral crown reminiscent of wickerwork banded with ribbons. Both her head covering and her long locks of hair, which hang down to her shoulders, are reminiscent of analogous elements in the representations of Isis-Aphrodite, numerous fragments of which were also found within and in the vicinity of the baths. These figurines frequently represent the goddess exhibiting her genitalia by raising her gown or appearing completely nude, standing with her hands pendant alongside her body. This gesture of stripping the body of clothes—suggesting a desire to ensure fertility—is also known from written sources, which contain accounts of pilgrimages of Egyptian women to the young bull Apis.

Of particular interest in the group of terra cotta figurines from Athribis is one that represents a woman who is clad and has her hair arranged in a manner typical of Isis. It is unusual that here the alleged

goddess, known in mythology as the mother of Horus, is in the company of two children, clearly both males, the younger at her breast and the older standing beside her. This surprising iconographic image becomes comprehensible when the mother is interpreted as representating Cleopatra I, who gave life to two kings of Egypt—Ptolemy VI and Ptolemy VIII. According to written sources, Cleopatra was in fact identified with Isis. Such an interpretation is also implied by the date of the figurine, deduced from stratographic data as the first half of the second century B.C.E. The queens of this time were identified equally readily with the Greek goddess of love and with the Egyptian goddess of fertility. We have, therefore, intriguing evidence that the cult of fertility was used for dynastic religious propaganda.

It is also appropriate to associate Isis with likenesses of a standing naked woman. These renderings are sculpted on miniature votive stelae made of

Isis and Osiris in relief on the reverse of a miniature votive stele. Ptolemaic Period, from the excavations at Tell Atrib.

Erotic scene in relief, decorating a faience vessel from the Ptolemaic Period. Fragment of a vessel from the excavations at Tell Atrib.

limestone and are often found in conjunction with the terra cottas just described. One of these women wears on her head a crown of the type commonly worn by Isis, consisting of tall cow horns enclosing the solar disc. The figurines described earlier that depict Bes and other male gods, as well as the female fertility symbols referred to here, were undoubtedly of a votive nature. The assembly of so many erotic objects in or near the baths suggests how these areas might have been used. The ritual bathing that took place here may have been associated with the preparation of women for childbirth—or ever with the birth itself, as suggested by the shape and size of the basins. These baths also certainly had a religious significance, as is confirmed by the presence of erotic votive figures. It cannot be ruled out that this was a small sanatorium of a prophylactic-religious nature—one of the many similar structures functioning at Egyptian temples during the Ptolemaic Period. Other objects found in large quantities at and around the baths suggest that this may also have been the site of intimate encounters combined with libations, similar to the *stibadeion* ("little nest"), the site of the cult of Dionysus, that was found in centers of Hellenistic culture outside of Egypt. Such an interpretation is supported by the discovery of beautifully decorated ceramic vessels, among which are many small amphorae with painted decorations, as well as glasses and saucers, and cups with imprinted relief decorations, the themes of which refer in some cases to the cult of Dionysus and in others to the cult of Isis and Osiris. In Hellenistic Egypt, the Greek god of wine

was identified with Osiris. Reliefs executed on other fragmentarily preserved vessels found near the baths depict erotic scenes—in general, different versions of *coitus a tergo*, performed in bed.

Both the ceramics and the votive objects just described were produced in local workshops, remnants of which were discovered by our team in the vicinity of the baths. In one of these workshops, there were fragments of many marble sculptures representing Aphrodite; in others, we found several molds that were used to imprint decorations on bread or other baked goods. Of particular interest to us were two molds that were used to duplicate scenes of an erotic nature: Eros sailing on a dolphin, and Eros playing the flute. The baked goods made using these molds were also likely consumed during the libations or other ceremonies carried out within the baths. By this means, they served, indirectly, the cult of fertility.

Phallic terra cotta figurines from the Greco-Roman Period

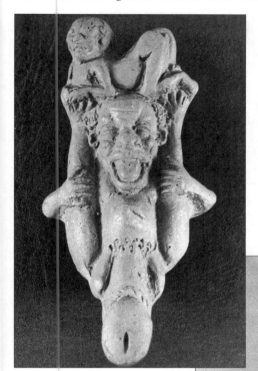

Obscene composition.

Phallophoric group from Saqqara:
phallus carried by two Beses and
two priests.

Man's head with female (yellow) skin color, forming the hieroglyphic sign *her*

Painting on an ostracon representing the sign *her*. New Kingdom.

Hieroglyphs *her* and *tep* (man's head in profile, with male—that is, red—skin coloration). Relief, Old Kingdom.

Fragment of shroud covering a mummy, composed of faience beads.

Dancing woman. Clay votive figurine of the Predynastic Period.

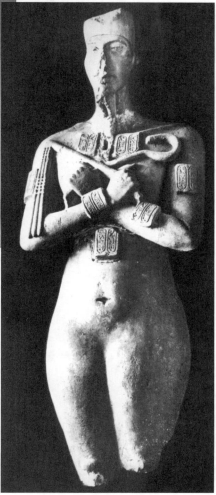

Naked ruler with hermaphroditic features.

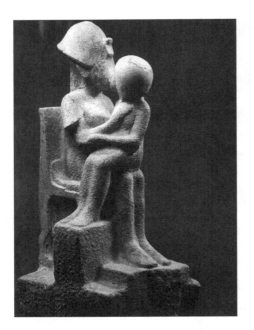

Unfinished statue of Akhenaten kissing one of his daughters.

The "heretic" pharaoh Akhenaten with his wife and daughters. Stele from Tell el-Amarna.

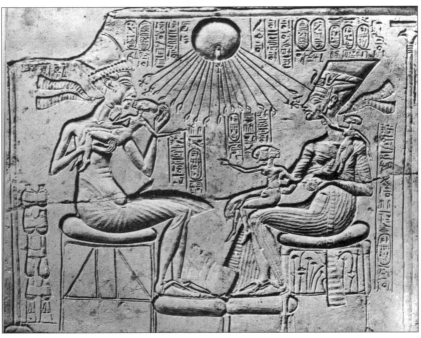

The god Hapy—personification of the Nile, guarantor of the fertility of nature and bountiful harvests in Egypt

Symbolic scene of the uniting of Upper and Lower Egypt. Relief on a statue of Amenhotep III, western Thebes.

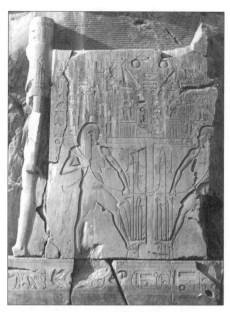

Relief from the Thirtieth Dynasty.

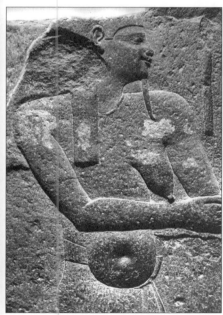

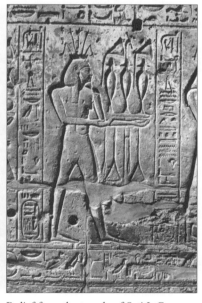

Relief from the temple of Seti I, Gurna.

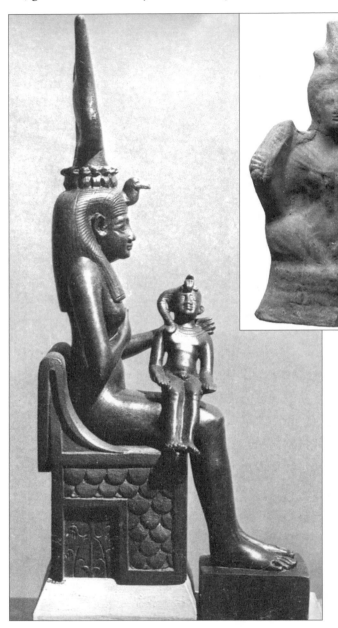

Isis sitting on a basket. Terra cotta figurine from the excavations at Tell Atrib.

Goddess with Horus-child on her lap. Bronze figurine, Late Period.

Public baths used for ritual bathing associated with the cult of fertility. From the reign of Ptolemy VI, at Tell Atrib.

Woman with swollen belly (perhaps pregnant), taking a bath. Fragment of a terra cotta figurine. From the vicinity of the public baths at Tell Atrib.

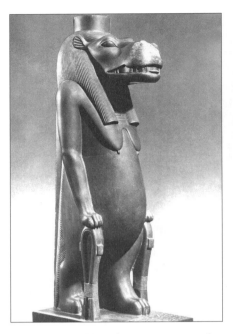

Statue of the goddess Thoeris, protectress of pregnant women. Late Period.

Miniature stelae with images of naked women. Votive offerings in the cult of fertility. From the excavations at Tell Atrib.

Naked woman with swollen belly. Terra cotta votive figurine of the Ptolemaic Period, from the excavations at Tell Atrib.

3

Apis and Other Sacred Bulls

The cult of the bull was known in Egypt from the earliest times. The ruler appears in the form of a bull on palettes dating from as far back as the Predynastic Period or the Early Dynastic Period. The first testimonies of this cult are recorded in the Delta region, which was an agricultural area where cattle breeding became established early on. The residents of Heliopolis worshipped a bull by the name of Mnevis who was black, had large testicles and a thick covering of hair, and was associated with the cult of Re and Atum. Mnevis was known as the herald of the sun god. Whenever one of the divine bulls died, he was embalmed and buried as a god with solemn ceremony. The records of Manetho suggest that this cult already existed at the time of the Second Dynasty. In Egyptian texts, however, the name Mnevis appears only in the texts of the Middle Kingdom (in the *Coffin Texts*), and the oldest known tomb of a deceased bull in Heliopolis dates only from the time of Ramesses II. Also revered in the "city of the sun" was a fetish in the form of pillars crowned by the heads of bulls.

In Upper Egypt, the primary object of worship was a bull by the name of Buchis, considered to be an incarnation of the god Montu. The chief center of the cult of Buchis was Hermonthis (present-day Armant), which lies to the south of Thebes. Buchis had a black head and a white body, which has led some scholars to identify this bull with the white bull

that participated in the festivities in honor of Min (described in chapter 1). This identification is, however, not certain. Buchis was enthroned by the pharaoh in the "presence" of the Theban god Amun. Buchis was revered not only in Armant (Hermonthis), but also in Medamud and Tod. Medamud was the seat of an oracle of Buchis. The sacred animal of the god Montu had assigned to it, over the course of time, certain of the characteristics of Mnevis, and thus was clearly considered to be a hypostasis of the sun god, or at the very least, a herald of Re. As in the case of the sacred bull of Heliopolis, Buchis was embalmed and buried in a special necropolis. The site of the burial was known as the Bucheum (the Latin version of the Egyptian name *Pr-Itm*, which signifies "the House of Atum"). This necropolis was situated in the vicinity of Hermonthis; nearby was a cemetery for the mothers of the subsequent Buchises. The oldest of the burials discovered at the Bucheum dates from the Thirtieth Dynasty (fourth century B.C.E.), while the most recent of these sites dates from the time of Diocletian's reign.

Especially predominant among the sacred bulls is the figure of Apis, the incarnation of the Memphite god Ptah, as well as of Osiris. The cult of Apis embraced the entire land of Egypt, but the site of residence and burial for subsequent Apises was Memphis. From the very beginnings of the Egyptian state, Apis was associated closely with the cult of the ruler, both in the theological sphere and in ritual. The pharaoh, bearing the title "mighty bull," was identified with Apis and, like Apis, was regarded as the guarantor of fertility and abundant harvests. For this reason, as early as the period of the First Dynasty, the pharaoh and Apis were represented side by side in the ritual run around the cultivated fields, particularly when the pharaoh appeared as the ruler of Lower Egypt. Even in the *Pyramid Texts* (the earliest known texts of Egyptian religious literature), the phallus of the deceased pharaoh is identified with the phallus of Apis; it was necessary to ensure the fertility of the ruler even after death.

Practically all the people of Egypt were involved in the life histories of the successive Apises. With the death of the sacred bull, it was necessary to find his successor. This was no easy task, since the anointed divinity had to possess certain physical characteristics. According to the record of Aelian, there were twenty-nine such distinguishing features, corresponding to the number of days of one phase of the moon. There was such a

close association between the sacred bull as the incarnation of Osiris and the moon as a nocturnal source of light that the procreation of Apis was attributed to a moonbeam.

The sacred bull of Memphis had black skin with white spots and a triangular mark on his forehead. The bull's back had a characteristic form that is clearly visible in the bronze figurines of Apis. Various additional requirements clearly reduced the number of candidates for succession to the throne, and on only one occasion was the successor of the deceased Apis chosen from among his offspring. The entire populace of Egypt participated in the search for a successor, and when at last a calf that possessed the requisite black body with white spots was found in someone's croft, the sensational news spread quickly throughout the entire land, leading to outbursts of joy. A special house was built for the newborn bullock and his wet nurses, in the form of milk cows, who nourished him until he was capable of bearing the rigors of a long journey. At this time, a group of priests brought the bullock to a locality known as Nilopolis, which was situated on the banks of the Nile but whose precise location has not yet been determined. According to the record of Diodorus, Apis remained at Nilopolis for forty days. This period was of particular importance to the women of Egypt, who made pilgrimages to the sacred bull and exhibited their genitals in front of him, thereby sharing in his fertility. This gesture is recorded in representations of Isis-Aphrodite lifting her dress to uncover her womb, a gesture that appears most frequently in terra cotta figurines of the Ptolemaic and Roman periods. A goddess of this type is represented in numerous terra cotta figurines from Tell Atrib.

It has been reported that the women who stripped in front of the young Apis were later prohibited from approaching the sacred bull. This information, provided by Diodorus, seems to be of doubtful accuracy, since Apis continued to take part in numerous processions to which no one was denied access.

Similar customs have survived in Egypt until very recent times. As late as the nineteenth century, archaeologists found that when an object representing a bull was unearthed, Arab women approached so that they might sit on this fertility symbol.

When the moon was full, the young Apis was transported by bark to his permanent place of residence in Memphis. The accommodations for

Apis comprised a south-facing annex to the temple of Ptah, where a special group of priests was assigned to watch over and protect him. Part of this structure was designated as the residence of specially selected cows, which, according to Diodorus, were at the disposition of Apis at all times. However, other sources indicate that Apis associated only once a year with a single cow that was chosen specially from among the residents of his "harem." As soon as their coupling was completed, the cow was reportedly slaughtered to eliminate the possibility of progeny. If, in reality, the rule was as stated, it was not rigorously adhered to, since there is reliable evidence in Egyptian sources of progeniture of the sacred bull. Archaeological discoveries have revealed the existence of large cow harems in the area of the residence of Apis.

The mother of the sacred bull was provided with lavish care similar to that accorded to her child. Special servants were assigned to her, and she was included in the rituals of the feast. The cult of the cow-mother was widespread in Egypt, where Hathor, in her role of sky goddess, also assumed the form of a cow. One of the most beautiful chapels of the temple of Queen Hatshepsut (Eighteenth Dynasty) at Deir el-Bahari (western Thebes), which was dedicated to Hathor, is currently the object of investigation by a team of Polish and French Egyptologists. On the walls of the sanctuary Hathor is depicted in relief, feeding her milk to the woman-pharaoh: The kneeling Hatshepsut sucks nourishing milk from the udder of the sacred cow, while a figure of the queen stands in front of the goddess, in the shadow of her head. Many later rulers are also depicted in a similar manner, with an emphasis on the source of the nourishment and the identity of their protector—apparently yet another instance of enlisting religion in the cause of dynastic propaganda. Other Egyptian goddesses are also depicted in the role of wet nurse to the king. In most cases, these goddesses are represented in anthropomorphic form: In the reliefs decorating temples, the ruler is often seen sucking their breasts. The breastfeeding Isis has even assumed the form of a tree, as represented in a painting on one of the walls in the tomb of Thutmose III (Eighteenth Dynasty), situated in the Theban Valley of the Kings.

Other reliefs, which represent the king in the embrace of goddesses, suggest still more intimate relations between the ruler and the female deities. But the divine origin and affinities of the pharaoh are recalled

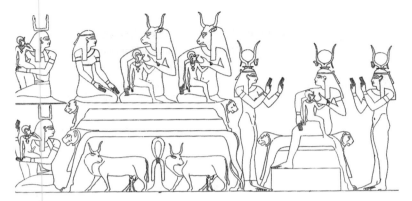

Divine wet nurses. Relief in the *mammisi* at Armant, Ptolemaic Period.

primarily in the coupling of the king's mother with the king of the gods, Amun, as recounted in the legend of the divine birth of the king. This legend is shown in relief on the walls of several temples of the New Kingdom, as is discussed in later chapters.

Returning to the cult of the bull in ancient Egypt, it is worth noting that according to the accounts of several writers of antiquity (from the first few centuries C.E.), the Egyptians killed Apis, by drowning, when he reached the age of twenty-five. However, this information seems fairly improbable in light of various Egyptian written sources. One of the stelae attests to the death of the sacred bull at the age of twenty-six; in addition, in the "negative confessions" referred to earlier, there is found, among other things, an assurance of the deceased that he has not killed the sacred bull. It is also worth mentioning here the indignation of Herodotus (fifth century B.C.E.) as a result of the sacrilegious killing of Apis by Cambyses, the execrable Persian ruler. Therefore, we have good cause to conclude that the sacred bulls of Memphis died a natural death. Following their death, these bulls were first embalmed, then buried, with great pomp and ceremony, in the precincts of the royal necropolis of Memphis.

Today, more is known of the posthumous fate of these sacred bulls than of their earthly lives. Several Egyptian written sources describe the funerary ritual for the Apises: During various historical periods, texts

were written on stelae that were set up or affixed to walls in the Ser-
apeum, the burial place of the sacred bulls. The right to place a stele in
the vicinity of the sarcophagus of a sacred bull was held by participants in
the funerary rites as well as by the Egyptians who underwrote a portion
of the costs of the (very expensive) burial. Among the most substantial
expenses was the huge stone sarcophagus that held the divine remains.
These gigantic coffins were at first placed in individual tombs but were
later positioned side by side in large subterranean galleries hewn in the
rock, not far from the oldest of the royal pyramids at Saqqara.

An important archaeological source of information regarding the
mummification of Apis's corpse is a series of large alabaster beds that were
discovered by archaeologists in the area of Memphis. One part of the fu-
nerary rites was the ritual of the opening of the mouth; in Egypt, this
ritual was also observed for mummies of dead persons, new statues, and
other objects. With the aid of special instruments, the mouth of the de-
ceased was opened—clearly, only in a symbolic manner—to make pos-
sible the "breathing-in" of life beyond the grave. This ceremony is one of
the various magic rituals intended to ensure the regeneration of the de-
ceased on the model of the resurrected Osiris. The identification of Apis
with Osiris united, over time, both gods in a single syncretistic deity,
known by the Greeks as Serapis. His partner was Isis, wife of Osiris. In
the Greco-Roman Period, Serapis was represented as a bearded man with
a calathus on his head. In time, the cult of Serapis, Isis, and Harpokrates
came to extend far beyond the borders of Egypt. Temples and chapels for
Egyptian gods were built in many parts of the Hellenistic world, as well as
across the entire Roman Empire.

4

Religious Aspects of Royal Power

DIVINE BIRTH

The anthropomorphic "mighty bull," as the pharaoh was considered to be, was also legitimized by his divine origin. Such a beginning is emphasized not only by his insignia, his attire, and the epithets accompanying his name but most of all by the legend of his divine birth. This legend recounts that the ruler was not the child of the pharaoh and his wife, but rather represented the fruit of the union of the pharaoh's wife with a god. In a literary version of this legend of divine birth, regarding the origin of the Fifth Dynasty (Old Kingdom), written during the Twelfth Dynasty (Middle Kingdom) and preserved on the so-called Westcar Papyrus dating from the Fifteenth Dynasty (Second Intermediate Period), the mother of three successive kings was the wife of a priest of the sun god Re, who lived in Sakhebu (western Delta). Since the story related to the transition from the Fourth Dynasty to the Fifth Dynasty, it may be assumed that its archetype was created during the Fifth Dynasty as a type of theological motivation intended for the seizing of power by people from outside the royal family. The mother of the first three kings of this dynasty, bearing the name of Ruddjedet, is generally identified with Queen Khentkaus, probably the mother of Userkaf, Sahure, and Neferirkare, who ruled from 2465 to 2427 B.C.E. In the literary version, the father of

the three kings was the god Re himself; the birth of each of these kings is described as follows:

> On one of those days, Ruddedet felt the pangs and her labor was difficult. Then said the majesty of Re, lord of Sakhbu, to Isis, Nephthys, Meskhenet, Heket and Khnum: "Please go, deliver Ruddedet of the three children who are in her womb, who will assume this beneficent office in this whole land. They will build your temples. They will supply your altars. They will furnish your libations. They will make your offerings abundant!"
>
> These gods set out, having changed their appearance to dancing girls, with Khnum as their porter. When they reached the house of Rawoser, they found him standing with his loincloth upside down. They held out to him their necklaces and sistra. He said to them: "My ladies, look, it is the woman who is in pain; her labor is difficult." They said: "Let us see her. We understand childbirth." He said to them: "Come in!" They went in to Ruddedet. They locked the room behind themselves and her.
>
> Isis placed herself before her, Nephthys behind her, Heket hastened the birth. Isis said: "Don't be so mighty in the womb, you whose name is 'Mighty.'" The child slid into her arms, a child of one cubit, strong boned, his limbs overlaid with gold, his headdress of true lapus lazuli. They washed him, having cut his navel cord, and laid him on a pillow of cloth. Then Meskhenet approached him and said: "A king who will assume the kingship in this whole land." And Khnum gave health to his body.[1]

Similar divine activity accompanied the births of the next two boys. In the role of the four female midwives and one male midwife—here, emissaries of the sun-god Re—were the goddesses Isis, Nephthys, Meskhenet, and Heket, and the god Khnum. A thousand years later, these same figures were represented playing a similar role in an iconographic version of the divine birth of the king. The oldest known examples of this pictorial composition—representing, in more than ten

[1] From "Three Tales of Wonder," Papyrus Westcar; M. Lichtheim, *Ancient Egyptian Literature: A Book of Readings*, vol. 1 (Berkeley, 1973), p. 220.

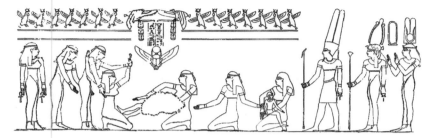

Birth of the divine child before Amun-Re, the goddess Nekhbet and Queen Cleopatra VII. Relief in the *mammisi* at Armant, Ptolemaic Period.

different images, the ensuing episodes of the legend—are the reliefs on the walls of one of the porticoes in the funerary temple of Queen Hatshepsut at Deir el-Bahari. This ruler, like the first kings of the Fifth Dynasty, had serious difficulties in establishing the political legitimacy of her reign. Hatshepsut had acceded to the throne by reason of her position as only surviving child of the four children of Thutmose I. At first, there were attempts to ensure the accession of a man as the Egyptian king, by marrying Hatshepsut to her stepbrother, Thutmose II, the son of one of the lesser wives of Thutmose I. Unfortunately, the young Thutmose II died soon after his accession, having produced with Hatshepsut two daughters but no male heir to the throne. However, Thutmose II did have a son, also called Thutmose, with one of his concubines. This Thutmose was married to one of the daughters of Hatshepsut, who was his natural half sister. Since young Thutmose III was not yet of age at the time of the death of Thutmose II, Hatshepsut (his aunt, stepmother, and mother-in-law) took over the kingdom in the role of regent. Hatshepsut, who considered herself to be the legitimate successor to the throne and who had the support of a significant portion of the royal court, had herself crowned. Thutmose III, whom Amun had "designated" king of Egypt, then began a struggle for the throne. When he finally succeeded, twenty years later, he set out zealously to destroy all traces of the reign of his predecessor. He ordered that the name and likenesses of Hatshepsut be chiseled from the reliefs on the walls of her temple. The name Hatshepsut was also omitted in later lists of rulers carved on temple walls and written on papyri.

During the bitter struggle for power, Hatshepsut tried to prove that she was indeed the legitimate ruler. For this purpose, she made use of political theology, which already had in its repertoire the concept of the miraculous conception and birth of the pharaoh. In an unusually suggestive manner, this concept proved that the father of the king was himself a god—in this instance, the god Amun, who was identified with the sun god Re, and who stood at the head of the Theban pantheon. The entire legend was expressed on the walls of Hatshepsut's temple in a cycle consisting of fifteen sequential scenes that represented successive episodes of the "divine birth"—a kind of propaganda cartoon on the theme of mythologized historical fact. These scenes have a beautiful artistic form, passing on, in abbreviated and symbolic form, an unusual wealth of information.

In the first scene, we see several of the most important gods of the Egyptian pantheon standing before Amun, who has summoned them to an audience. Amun himself is seated on a throne. The only one admitted separately is the god of wisdom, Thoth, advisor to the king of the gods. To him Amun entrusted the highly important task of searching out the female candidates for the mother of the divine child, that is, for the earthly concubine of the demiurge. Thoth had to bring the chosen one to the "home of the prince," clearly a specific place in the temple of Amun-Re at Karnak. The selected woman was the queen Ahmes, the future mother of Hatshepsut; then there began an adventure of love between Amun and a beautiful stranger, who was only later revealed by Thoth to be the queen. To possess her, Amun assumed the form of her husband, Thutmose I, and proceeded to the bed of the queen.

The text describing Amun and Ahmes's connubial life is full of subtle and amorous passion. Amun enters the palace to awake the sleeping queen. He charms her with his sweet smell and his beauty, and the pair couples. During this event, the god pronounces the name of the future ruler, Hatshepsut, who receives his soul and crown and therefore becomes ruler of all of Egypt. In a scene illustrating their coupling, we see a bed on which are seated two goddesses, Neith and Selkit, who support the symbol of the sky. On the bed are also seated the pair of lovers, the god and the queen, crossing their legs. Tenderly caressing the hand of his partner, the god holds up to her mouth the sign of life, which symbolizes the beginning of a new life during the amorous encounter.

The god Amun-Re and Queen Mutemwia, in a scene showing the conception of the royal child, Amenhotep III. Relief in the temple of Amenhotep III at Luxor.

In the next scene, Amun confers with Khnum, the god responsible for forming the fetus. Khnum had experience in such matters, since he himself made people on his potter's wheel. The king of the gods entrusted Khnum with forming the ruler, together with her *ka* (spiritual double), so that she should be blessed with good health and happiness. In response, Khnum promised to create a pharaoh possessing a form more magnificent than that of the gods. Amun further and precisely defined his desire: The body of the future ruler must be his own body, so that it should have the form and likeness of the god. The subsequent scene shows Khnum at work. On his potter's wheel, he forms a pair of naked children with the aid of the frog-goddess Heket, who blesses the newly born, breathing life into them.

Pregnant queen being conducted to the place of birth by the gods. Relief in the temple of Hatshepsut at Deir el-Bahari.

In several of the subsequent scenes the child is seen as inseparable from her double, the royal *ka*. The period of pregnancy included a conversation of the mother with Thoth, who showered the queen mother with honorary titles and then, together with Khnum, led her to the place of childbirth. This scene is noteworthy for the fact that the pregnant queen is represented as being clearly pregnant, which is quite unusual in Egyptian art.

The central episode of this cycle is the large birth scene. Here, the queen mother is shown in a seated position, surrounded by many deities and genii who are assisting at the delivery and blessing the newborn child. The scene takes place on a gigantic bed. The male midwife and female midwives are already known to us from the Westcar Papyrus. Amun arrives to inspect the child and to acknowledge her as his own. The jubilant father passes the child to the goddess Hathor, whose role is to suckle the future ruler as well as to protect her during her minority. In the next image, we see the child with a variety of wet nurses. Hathor is shown breastfeeding the infant in the presence of the queen mother. The bot-

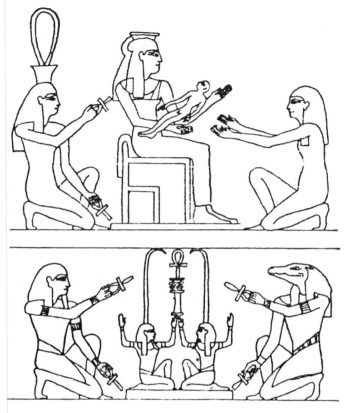

Scene of the birth of Queen Hatshepsut. Relief in the temple of Hatshepsut at Deir el-Bahari.

tom, or third, register of the tableau contains two parallel scenes that represent the newborn infant and her *ka* sucking the udder of the sacred cow. A bit further along we see two children being held by two ancient gods, Hekau (magic powers) and Hapy (the Nile), who are bearing the children to the Nine Gods in the part of the royal palace known as the "chapel of magic spells." This chapel, it would appear, was the site of a purification rite reminiscent of baptism, as well as a ceremony presenting the child to the palace deities.

The final scene follows a brief conversation between Amun and Thoth, which has been interpreted as the symbolic dressing of the child and the imparting to her of royal dignity. The scene represents an act of circumcision. Although the text accompanying this scene does not inform us of the child's age during this ceremony, we can infer—from written sources as well as the fact that the child is shown standing—that the child was approaching the age of majority. The chronicler-goddess Seshat is standing nearby recording the event, wishing many years of prosperous reign to the successor to the throne. Immediately after the birth cycle, in the decorations of the temple of Hatshepsut, is a sequence of scenes illustrating the coronation of the queen as the ruler of Egypt.

The joint achievement of theologians and artists from the reign of Hatshepsut was often repeated in later periods. Such affirmation of the divine origin of the pharaoh and legitimization of his royal power became particularly important when the right of succession to the throne was in doubt. One of the most complete iconographic versions of this legend survives in the reliefs of Amenhotep III (1417–1379 B.C.E., father of Akhenaten). The reliefs are carved on the walls of one of the rooms in the temple which this ruler had built at Luxor. This version differs, in certain essential details, from its prototype created for Hatshepsut. Amun's courting of the beautiful stranger, otherwise a queen, is represented here less abruptly, and the aspect of matrimonial infidelity committed by the latter has been toned down, with the king's approval regarding his consort's extramarital liaison with a god. At first glance, this myth might appear to compromise the royal couple, representing the queen as a harlot and the king as a cuckold. Any potential ambiguity, however, was removed by the introduction of a new episode preceding the conception. Amun sent to his chosen one an intermediary in the form of Hathor, goddess of love, who embraces the queen while the "commission-giver" himself stands aside and looks on—perhaps in order to estimate his own chances of success. In addition, the god himself speaks with the husband of his chosen one—the currently reigning king. Although the words which the god addressed to the king are not preserved, one may assume that the king gave his consent. This is the only time in the entire myth when the pharaoh—the actual father of the child—appears. The pharaoh's name is mentioned in the text only when the queen mother

must be represented as his wife, and when Amun, on his way to the royal bedchamber, assumes the form of the pharaoh.

The difference between the original version and the copy made during the reign of Amenhotep III also relates to the scene with the potter-god Khnum. At Luxor, Hathor is represented as Khnum's assistant, in place of the frog-goddess Heket, who occupies this position at Deir el-Bahari. Perhaps a distant echoing of the symbolism of the frog as a witness to childbirth is evident in early Christian Egypt by a type of small oil lamp decorated with a representation of a frog in relief on the disc of the lamp. Lamps of this type were probably lighted during the birth of a child. It is possible that such lamps were also symbols of rebirth, since they have been found, among other places, in tombs.

The image of the body of the frog on several lamps of this type is quite stylized—either simplified or turned into a motif of different content. A particularly interesting recasting of this fertility symbol is a relief depicting two infants reaching their hands out toward the vagina, shown symbolically as a circular cavity on the surface of the lamp. A lamp of this type has been unearthed, for instance, in the Byzantine stratum of ancient Athribis.

In the coroplastic art of the Ptolemaic Period, one also encounters a unique representation of a phallic "frog-warrior," wearing armor on his chest. The frog is fighting against a muscular animal with a shield, also distinguished by a disproportionately large phallus. Although the head of this animal has not survived, it is undoubtedly a mouse—reference to a parody of Homer's *Iliad* by writers of the Hellenistic Period, in which war broke out as a result of the murder of a mouse by a frog. This figurine was found by the Polish-Egyptian archaeological team at Tell Atrib, together with other erotic terra cotta figurines that were described earlier.

The temple at Luxor was associated with divine birth in a special way. There is a suggestion of such an association in its very name—"South Harem" (*Ipt-rst*), which also implies a functional link with a cult having sexual aspects. This is confirmed by the numerous representations of Amun-Kamutef in the reliefs carved on the temple walls, which also indicate the importance of the role of "god's wife of Amun" in the temple processions. These rites, which symbolized the conception of a ruler by the coupling of the god and the queen, may have been a part of the rit-

ual that was performed here during the annual festival of Opet. At that
time, a procession bearing statues of Theban deities made its way from
the temple of Amun-Re, at Karnak, to the South Harem, stopping along
the way at specially constructed chapels, where various rites were cele-
brated. This public migration of the deities provided, above all, an op-
portunity for the oracle to be heard. Unfortunately, the precise nature of
the ceremonies that closed the festival in Luxor remains unknown. The
procession returned to Karnak along the Nile, in barks.

The mutual visiting of deities whom Egyptian theology associated
with family ties was widespread in Egypt. Encounters of this type took
place during festivals and were associated with journeys along the Nile,
processions, and other ceremonies. During the Ptolemaic-Roman Pe-
riod, among the most renowned of these meetings were those that in-
volved Hathor, worshipped at Dendera, and Horus, who resided at Edfu.
Each of these deities had a magnificent temple at the place of their cult.
Once a year, there was a ceremony known as the "Goodly Reunion." At
this time, the goddess Hathor embarked on a ceremonial voyage along
the Nile from Dendera to Edfu, where, for a period of fourteen days, she
remained with her husband. Throngs of the faithful, coming from vari-
ous sites between the two cult centers, participated in these festivities.
Hathor then returned to her permanent residence at Dendera. The daily
meetings of Min, the local god of Koptos, with Isis, his mother and wife,
were also regarded as marital visits. The goal of the visit was for the god-
dess to see "his beauty"—that is, his phallus. Ptah of Memphis visited his
daughter Hathor, "Lady of the Sycamores," while Ptah of Edfu called on
his daughter at Dendera.

Conceptions regarding the divine birth of the king, as well as of the
births of the gods themselves in relation to the cult of the king, attained
particular significance during the Ptolemaic Period. At this time, the
walls of temples were decorated with representations of the cycle of the
divine birth, and, in addition, a special small sanctuary was built near each
main temple. Whereas the main temple was dedicated to the chief deity
of the local pantheon, this smaller sanctuary commemorated the birth of
the child god of the local triad. It functioned primarily as political prop-
aganda, with the Greek rulers of Egypt (who resided at Alexandria) in-
tent upon proliferating, throughout the heart of the land, evidence of

their descent from the Egyptian gods. These small sanctuaries, referred to colloquially as *mammisi* (from the Egyptian designation *pr-mst* = "house of birth"), were dedicated to the child-god, the youngest member of the divine triad that was worshipped at a particular cult center. At Dendera, this child was Ihi; at Edfu, Harsomtus; and on the island of Philae, Horus. The oldest known *mammisi* dates from the reign of Nectanebo I (Thirtieth Dynasty) and is situated at Dendera.

Carved on the walls of all the "birth houses" are reliefs whose subject matter is similar to that of the birth cycle just described, found in the temples of the New Kingdom. However, in contradistinction to the latter, these reliefs represent the birth not of the king, but of the young god of the local pantheon. Changes to these reliefs were made during the Late Period, perhaps during the rule of the Persians, whom it would have been difficult to regard as children of Amun. Certain fundamental differences in relation to their archetypes of a thousand years earlier can be explained, to some extent, by liturgical calendars concerning the festivals celebrated in the *mammisi*. Two such liturgical calendars contain the information that the "house of birth" was the site of the "mystery of the divine birth" (which must have comprised liturgical performances similar in their form to other dramas performed in Egyptian temples), attested to most extensively for the Ptolemaic Period. In contrast to the birth scenes dating from the New Kingdom, in which the divine nature of the royal child of Amun was emphasized, in analogous scenes from the Ptolemaic Period there is an emphasis on the royal aspect of the young god. Amun and Thoth speak of his reign on earth as Horus—that is, as the ruler of the Two Lands. The son of Isis, whose duty was to embellish the temples of the gods and to create their statues, is therefore identified with the living king. Khnum speaks of this duty ever more literally: "He will fulfill the role of a king on his throne, in order to unite the inheritance of the Two Lands."

Another difference between the comparable birth scenes from the New Kingdom and the Ptolemaic Period is that in the latter, the divine infant appears alone, without his *ka*. The symbolism of this double, often bearing on its head one of the most important names of the ruler—the so-called Horus name—lost its significance when the newborn child ceased being the king and was replaced by the god. However, there ap-

peared at this time a new element: a scene depicting the presentation of the child to the populace of Egypt. There is evidence of such an event only in the temple on the island of Philae (the center of the cult of Isis, situated on the southern border of Egypt). It accompanies a scene representing the reception of the newborn child by Amun, with the king being depicted as a priest, holding in his arms the divine and royal fruit of Hathor. The king, with the child, is shown approaching a place filled with representatives of the various ranks of Egyptian society, from the patricians (*pat*) through the populace (*rekhit*) to the "sun people of Heliopolis" (*hnmmt*). This scene provides a key to understanding the political role of the "birth houses" during the Greco-Roman Period: In these structures, the rulers of foreign blood were promoted as pharaohs who were the direct descendants of the Egyptian gods.

One of the subsequent scenes represents the enthronement of the child by two archaic deities so that he should become the "king of Egypt and ruler of the desert." Other texts expand the scope of his kingdom, speaking of a cosmic kingdom. In the next scene there appears, among others, Anubis, who bears a large disc that is referred to in the accompanying text either as the moon—guaranteeing childhood and ensuring the newborn child universal reign—or as a drum—awakening the world to joy on the occasion of the birth of the child. The god carries out the "confirmation" of the god-king in front of the Great Nine; at the end, the child is shown being fed by Hathor with her own breast, completing the goal of identifying the ruler with the god. The latest known illustration of this "miracle" is found in reliefs decorating the walls of a "birth house" dating from the reign of Trajan (second century C.E.).

The divine birth was the first of many acts that identified the pharaoh with the god. The successor to Horus had to confirm the divine nature of his rule every year, providing verification in the presence of both the gods and the people. The occasion for this confirmation ceremony was the annual celebration of the new year, which included rituals reminiscent of those of the enthronement ceremony. These ceremonies were celebrated at Heliopolis, the chief center of the cult of Atum. This localization, by itself, made it possible to associate the pharaoh with the solar demiurge—the creator of the gods. The liturgy of this festival has been preserved on one of the papyri dating from the late fifth century or early

fourth century B.C.E. Among the most important episodes here is that of the "rebirth." The king has lain down and fallen asleep; above his head are inset four seals bearing the names of gods. Two of the seals bear the name of Geb, one the name of Neith, and one the name of Maat—the goddess of truth and order. This rite symbolized the death of Osiris and his subsequent rebirth in the form of Horus. The seals were tokens of a divine heritage that emanated into the nature of the earthly god during sleep, providing him with the energy necessary for continued rule.

The symbolism of regeneration was particularly evident at the time of the *sed* festival, which was celebrated (at least in theory) in the thirtieth year of the king's rule—his accession to the "throne of Geb." Numerous iconographic representations of this ceremony depict the pharaoh in the form of Osiris, wearing now the crown of Lower Egypt, now that of Upper Egypt. The resurrected god has clearly assumed the form of Horus, the divine prototype of the pharaohs. Two of the five names of every pharaoh identify him as the son of Osiris. The Horus name was often written in a rectangular frame that also contained a symbolic representation of the facade of the royal palace, and there was also the so-called Horus-of-gold name.

The notion of the divine birth of the king enhanced the prestige of the queen mother as the female partner of the king of the gods; it also bears witness to the high rank of the queen mother at the Egyptian court. The oldest known evidence of her role as "first after the god" is recorded in the royal annals of the Fifth Dynasty, which are carved on the Palermo Stone. There, her name accompanies the name of the ruler in the register of the reign of every pharaoh. However, the title "mother of the king of Upper and Lower Egypt" is found only at the beginning of the Third Dynasty (ca. 2640 B.C.E.), beside the title "daughter of the god."

GOD'S WIVES OF AMUN

At the turn of the Second and Fourth Dynasties, there appeared two highly individual royal mothers. These women did not bear the title of "princess" or "wife of the king" but were instead promoted to the title of "royal mother" through the coronation of their sons (several sons, in the latter case). The first of these women, Ni-maat-hap, was the wife of

Khasekhemwy, the last ruler of the Second Dynasty. She bears the title "mother of the king of Upper and Lower Egypt" in an inscription dating from the time of Djoser (beginning of the Third Dynasty). The second is Khentkaus (referred to earlier), who was the mother of the first three rulers of the Fifth Dynasty. Her status must have been close to that of a deity, since it enabled her—according to the account of Manetho—to usurp the pyramid of the last ruler of the Fourth Dynasty and, subsequently, to enjoy a cult in a funerary chapel specially constructed for this purpose. This chapel was situated next to the pyramid of her youngest son, Neferirkare. There is nothing to indicate whether either of these queen mothers was able to legitimize her royal origin; however, the divine origin of each of their sons was emphasized in an ostentatious manner. Ni-maat-hap's son Djoser had built for himself the first stone pyramid in history, while the three brothers who reigned successively at the beginning of the Fifth Dynasty figured in a legend that appears in Papyrus Westcar.

Both of these cases indicate that the dogma regarding the divine origin of the king played an important role in the political history of Egypt. Any potential usurper to the throne could make use of this fact: If his mother were to play the part of the queen mother, independent of her authentic origin, he could designate himself the new pharaoh, thus leading to a dynastic change.

The queen mother played an equally important role at the beginning of the Eighteenth Dynasty. Ahmose, the founder of this dynasty, paid considerable attention to the "mother of his mother"—that is, his grandmother, Tetisheri. At Abydos, the center of the cult of Osiris, he ordered the erection of a cenotaph in her memory and commanded that he should appear two times on the stone stele that had been erected there, in the company of his grandmother, whom he "loved above all other things." The text of this stele, unusual in its form, consists of a conversation between the king and his wife, Ahmes Nefertari, "royal daughter and sister, wife of the god, great royal wife," who was later deified and worshipped for several centuries, together with her son, the renowned Amenhotep I. In another text, Ahmose also commands his subjects to pay fitting tribute to his mother, the queen Ahhotep.

The subsequent history of the Eighteenth Dynasty confirms that

within the hierarchy of women associated with the king during his lifetime, the first place was occupied by the queen mother (in some cases, the royal mother-in-law, if she was still alive), followed by the king's wife. The queen mother was most often depicted with the hide of a vulture (the sacred animal of Nekhbet, goddess of maternity) and two tall feathers from a falcon (sacred animal of Horus, with whom the king was identified) on her head. This is the manner of representation of Ahmes, the mother of Hatshepsut, when she appears in the role of mother-in-law of Thutmose II in a scene carved in the temple at Deir el-Bahari. These observations are also supported by the scenes painted on tomb walls during this period. In decorations in the tombs of dignitaries, the king is initially represented only with his mother, never with his wife. Later, in the Ramesside Period (Nineteenth and Twentieth Dynasties), the role of the queen mother diminished. A significant part of the prestige of the queen mother—or, at any rate, of her political significance—was apparently passed on to a designated "god's wife of Amun" (as a rule, one of the royal daughters).

Ahmes Nefertari achieved a posthumous cult, not because she was the wife of Ahmose but rather because she was the mother of the great Amenhotep I. Her unusual career began with performing the function of second prophet at Karnak—which, as a rule, was consigned to a male priest. It is not known what forced her to resign from this honorable post, although in a related text we read that she received from her husband, in compensation, a wealth of goods and land. Most likely, this gift was earmarked for maintaining the college of priests at the institution known as the "seat of the god's wife (or adoratrice)." Ahmes Nefertari became the first queen to bear the already existing title of "god's wife." In later times, those who held this position played an unusually important political role; however, during the time under consideration here, it was associated primarily with performing specific priestly activities. In one of the scenes carved at Karnak, Ahmes Nefertari is shown carrying out the duties of a common priestess. On the basis of surviving sources, it may be assumed that the king effaced himself in the shadow of his consort. However, the real increase in her importance must have occurred only after the death of her husband, when the queen acted as regent during the minority of her son, Amenhotep I.

During the time of the New Kingdom, the title "wife of the god" was often accorded to renowned royal wives and princesses. Later, from the Third Intermediate Period until the rule of the Saites (Twenty-sixth Dynasty), this title was bestowed on virgins dedicated to the service of Amun. The main theological function of these "divine adoratrices" was the assurance of cosmogonic procreation through association with the primeval god. For this reason, they were sometimes called "the god's hand." As early as the lifetime of Ahmes Nefertari, the title of "god's wife" was passed on to her daughters or daughters-in-law. From the middle of the Eighteenth Dynasty on, this title was apparently no longer accorded to princesses but usually to priestesses who were not associated with the royal family. This title was borne anew by several queens and princesses of the Ramesside era; however, it is not known precisely what criteria determined their nomination or selection. It can be stated that, in general, at the time of the New Kingdom, when this title was always "the god's wife of Amun," not all of the queen mothers were "wives of the god," and not all of the "divine adoratrices" were mothers of a king.

All the women who bore the title of "wife of Amun" were identified with the goddess Mut. Among the epithets for these "divine adoratrices" are also found the designations "daughter of the god" or "daughter of Amun." The prototype of this concept was the goddess Tefnut, the daughter of Atum, who guaranteed the procreation. The titles accorded to these women even referred to their sensuous attributes—"lady of grace," "sweet of love" or "great of love," "she of the beautiful face," "she whose beauty appeases the god," "charming one," and "mistress of all women." Some of these epithets were also assigned both to goddesses and to queens not bearing the title of "god's wife."

When taking part in cult ceremonies, the "wives of Amun" performed activities similar to those carried out by the other priestesses, including primarily singing and playing the sistrum. They are also represented at the time of their purification, prior to entering the temple. Their special duty, carried out jointly with the "fathers of the god" and with other specialized personnel, was participation in rituals for maintaining both the divine and human worlds. These wives summoned the gods so that they could receive their evening meal, took part in a magical ceremony in which an enemy was destroyed by burning his effigies, carried coffers

filled with sacred fabrics, and participated in some of the episodes of the funerary ceremonies.

The religious and political significance of the "god's wives of Amun" increased considerably after the fall of the New Kingdom, during the first millennium B.C.E. This office was held for a period of several hundred years by virgins of royal blood who, at Thebes, created actual dynasties that paralleled the royal dynasties. During this period, the rulers of Egypt resided primarily in the northern part of the land. Each of the successive "wives" adopted her successor, thus ensuring the continuity of the office. Most often, an aunt adopted her niece for this purpose. In view of the intensive contact between Egypt and Western Asia, where there were often cases of "sacred prostitution," attempts have been made to place a similar interpretation upon the role of the "god's wives" in Egypt. However, this conjecture is not supported by any Egyptian source, despite the fact that among the epithets bestowed on the virgin wives of the god there is a reiteration of such designations as "she who unites with the god," "she who comes together with the god," or "she who comes together with the members of the god"—sentiments that are shown in certain reliefs representing these women in intimate contact with the god. The scenes that depict Amun and his "wife" gazing into each other's eyes or rubbing their haunches together, or that show Amun giving his female partner the sign of life—a symbol of their union—and saying "my heart is greatly gladdened," are not without sensuality. One of the surviving statues even shows Amenirdis I, a "god's wife" of the Twenty-fifth Dynasty, sitting on the knees of Amun. The basic purpose of royal daughters carrying out these functions was, therefore, the "satisfying of the god."

This conclusion, however, does not alter the fact that these women exercised almost unchecked power over the region of Thebes and were also important political instruments of the kings who resided at Memphis or Sais. When a daughter of the Kushite ruler Kashta (Amenirdis I) was adopted by Shepenwepet I, daughter of Osorkon III, the rule of Thebes came into the hands of women related to the rulers of the Twenty-fifth Dynasty. Like the pharaohs, these rulers had their names carved inside a cartouche. In their titles there appeared epithets similar to those of kings: "Mistress of the Two Lands" or "Mistress of Appearances." They were also responsible for building sacred edifices, on the walls of which they

are represented in relief, performing ritual activities that were more typi-
cally performed by the ruler. Several of these temples were established
jointly by a "wife of Amun" and the reigning pharaoh. Some of the dig-
nitaries of the realm felt obligated to emphasize their dual loyalty, even in
the inscriptions carved on the surfaces of their own statues. One arm of
the person represented was adorned with the cartouche of the reigning
king, while the other bore the cartouche of the "god's wife." The funer-
ary chapels of the "divine adoratrices," dating from the times of the
Kushite Dynasty, were built within the compass of the funerary temple of
Ramesses III at Medinet Habu.

The ritual functions of the divine maidens of Kushite blood were ex-
tended to include all the king's duties in relation to the cult: They could
worship the god, make offerings (including offerings in the form of stat-
uettes of Maat, the goddess of truth and order), participate in the ritual
dedication of temples, and even perform the *sed* festival (celebration of
the jubilee of the reign). The "divine adoratrices" of this period main-
tained a very large court at Thebes, at the head of which was the major-
domo. In scenes carved on the temple walls, the majordomo frequently
accompanies the priests, while during the reign of the subsequent dy-
nasty (the Saite, or Twenty-sixth Dynasty), the majordomo nearly always
appears at her side, almost like the royal *ka* that appears by the side of the
pharaoh. The significance of the dignitaries who administered the do-
main of the royal daughters in the service of Amun is emphasized by the
fact that their tombs (e.g., those of Pabasa, Aba, and Ankhhor) are among
the most magnificent at the necropolis of Thebes.

The apogee of the power of the "god's wives of Amun" came during
the reign of the dynasty originating at Sais, which took over the kingdom
from the Kushites. The transferral of this office to Nitokris, the daughter
of Psammetichus I (who at that time was still not of age), was carried out
by diplomatic means. She was adopted—"with pleasure"—by the daugh-
ters of the Kushite kings, Amenirdis II and her designated successor, who
never succeeded in assuming office. The surviving portion of a stone
stele on which is carved a text recounting the adoption of Nitokris con-
tains a list of donations—primarily of land—that the king and various
dignitaries (the latter certainly not completely of their own free will) be-
stowed on the girl of royal lineage. According to the text, she had been

removed by force from her familial home and then moved to a region far to the south, where she was compelled to submit to a state of lifelong virginity. The donated land, scattered about in different parts of Egypt, totaled some nine hundred hectares. In addition, the dignitaries and priests of the various temples had to provide a daily supply of bread as well as monthly rations of cattle, geese, and other foodstuffs.

The successors of Nitokris, Ankh-nes-nefer-ib-re and Nitokris II, also carried out the function of "first prophet" of Amun at Thebes. They were placed at the head of the local priestly hierarchy and, as a result, acted there as absolute rulers. Like their predecessors, these two women were distinguished by their longevity. Ankh-nes-nefer-ib-re, the daughter of Psammetichus II, assumed this office in 584 B.C.E. and remained in power up to the time of the Persian invasion in 525 B.C.E. These "god's wives of Amun," who were not worn out by pregnancy and childbirth, lived in political seclusion—as did Thebes itself—at a time when there was a great deal of political activity in Northern Egypt. Although the relationship between the officiating high priestess and her adopted successor was sometimes characterized by the words "mother" and "daughter," this terminology possessed a purely legal significance and was not indicative of any actual familial ties.

The Persian kings of Egypt (Twenty-seventh Dynasty; 525–404 B.C.E.) did not carry on the tradition of appointing their own daughters to the office of "god's wife of Amun." As a result, toward the end of the sixth century B.C.E. there was a complete collapse of the political significance of the priestesses who held this office. According to both Egyptian and Greek sources, however, the existence of Theban priestesses bearing this title continued up to the Ptolemaic Period. Herodotus wrote of a woman staying overnight at the temple of Zeus and having no ties to any man. Later authors added their own interpretation, which placed the "wife of the god" in a substantially less complimentary light.

There were also harems of specific gods, which mirrored the role of "god's wife" among the lower orders of the priesthood but with other duties, and without the condition of celibacy. Priests created harems of various female deities, such as Isis, Nekhbet, Hathor, and Bastet, while priestesses belonged to similar congregations dedicated to male deities, such as Iunmutef, Min, Wepwawet, and, above all, Amun. The oldest

known harem of a goddess dates from the Sixth Dynasty, while harems of male gods first appeared during the First Intermediate Period. Priestesses from these divine harems were usually shown dancing, singing, or playing the sistrum; ritual activities associated with music were apparently their chief occupation.

SIGNIFICANCE OF THE ROYAL HAREM

We must now consider the question of the precise role of the Egyptian queen, beyond that of queen mother and "god's wife"; that is, beyond the functions ensuring her own place in history. Here, we are more interested in the position of the king's wife as a woman. From this standpoint, her role was quite complex, since the king—in contrast to other Egyptian men—had the right to be polygamous. Although Egyptian marriage was usually monogamous, the pharaoh maintained at his court numerous women with whom he had intimate relations. The "great king's wife" nonetheless stood at the head of the royal harem. Unlike the Turkish royal harem, the Egyptian harem was housed in a separate part of the palace, had its own administration, and was managed by a harem steward. The harem owned land, herds, mills, weaving workshops, and other establishments. Assembled in the harem were both princesses and women of lower social standing who, with the goodwill of the ruler, might achieve promotion even to the rank of "great king's wife." During the New Kingdom, the harem was not lacking in foreigners, primarily "Asiatic" (Middle Eastern) princesses—the daughters of Hittite, Babylonian, Mittanian, and Syrian kings. Along with the daughters of the king and his concubines, the harem also contained royal children and the progeny of favored office holders of the royal court. The harem was, therefore, among other things, an elite institution that raised children and prepared selected boys to assume the highest offices at the royal court. The harem also organized the social life of the royal palace, supplying the king with female dancers, singers, and musicians for various occasions.

A knowledge of the intricate social structure of the harem naturally implies, as might be imagined, that this important institution became the flash point of the royal court. Ambitious ladies of the harem were rivals in many areas; the basis of numerous conflicts was the issue of the succession

to the throne. Each of these women wanted to be the mother of the future king and to advance to the position of "great wife." Encouragement was provided by past events—for instance, events that took place during the Old Kingdom, when a dynastic transition was associated with the advancement of a woman of lower social rank to the role of "great wife." Plots and conspiracies—some of which nearly resulted in the death of the king—were daily occurrences within the harem. The first known case of this type took place during the Sixth Dynasty, and the best known literary account of similar events is preserved in the tale of Sinuhe, dating from the Twelfth Dynasty. In this tale, an official associated with the harem flees to Phoenicia, as a result of certain bloody events that had led to the death of Amenemhet I, the founder of the dynasty.

The best known of the harem plots was that directed against Ramesses III; its details are preserved on fragments of papyri, which contain an account of the trial of the accused conspirators. The main cause of this conspiracy was the conflicting claims of women within the harem. The king had chosen none of them as his "great wife," which left the question of succession unresolved. The organizer of the plot was Tiyi, one of the concubines of the king. Tiyi was obsessed with the succession of her son to the reins of power. Although her efforts were supported by women of the harem as well as several high-ranking officials, this attempt on the life of the king ended in a fiasco: The conspirators were brought before the court, where some were sentenced to death and others had their ears and noses cut off.

How, then, did the "great king's wives" make their way safely amid this tangle of intrigue? Their position was certainly not an easy one. Most likely, many of them lived in constant fear and anxiety, wondering if some new romantic object of the king would prove detrimental to their privileged position. Such fears were not groundless, as indicated in the biography of Ramesses II (1304–1237 B.C.E.). In his harem, seven women bore the title of "great wife," while written sources inform us that his issue from these marriages included at least forty daughters and forty-five sons, and the successor to the throne was his thirteenth son, Merenptah. In the thirty-fourth year of his reign, Ramesses entered into a famous political marriage with a Hittite princess, the eldest daughter of Hattusilis III. This, however, did not prevent him from marrying yet another Hit-

tite of royal blood, as well as two other Asiatic princesses—one from Babylon, the other from northern Syria. Such royal marriages were often simply political acts that were intended to cement alliances and had no association with love. Within these marriages, however, there is evidence, both written and iconographic, of the great affection of certain royal couples. Nevertheless, the position of the "great wife" became decidedly more permanent only when the queen became the mother of the successor to the throne.

The role of the queen altered over the span of some three thousand years of Egyptian history. Apart from the individuality of each of the spouses—an essential factor up to the present day—an important role was also played by certain general trends that were emerging from the ongoing sociocultural development of Egypt. During the New Kingdom, for example, in the first half of the Eighteenth Dynasty, the dominant force at the royal court was the queen mother. However, this situation underwent a radical change during the reign of Amenhotep III, when the importance of the mother was assumed by the wife, who was identified with the goddess Maat. The "great king's wife" began at that time to be considered the guarantor of truth, justice, and order within the realm.

This situation was consolidated during the period of "religious heresy" in the reign of Amenhotep IV/Akhenaten. Together with Aten (the deified solar disc), the king and queen created a divine triad. Representations of this royal family are replete with naturalness and intimacy, as illustrated by numerous kissing scenes. This may be interpreted to mean that Akhenaten and his wife—the beautiful Nefertiti—lived in truth, whose incarnation is the wife of the ruler, Nefertiti herself. Queen Teye, the wife of Amenhotep III and mother of Akhenaten, is represented as a sphinx trampling foreign women, and even Nefertiti appears in Egyptian art as the conqueror of foes, striking a regal pose. Such images indicate that the wives of the last two Amenhoteps had attributed to them typically "male" functions, which were traditionally the portion of the king. Despite the strong position of the "great wife," in the twentieth year of the king's reign, the first of these two Amenhoteps also took as his wife Giluhepa, daughter of the king of Mittani. In the thirty-fifth year of his reign, he cemented a friendship with this Asiatic kingdom through a marriage with a second princess of the same blood; upon the death of the

pharaoh, she passed into the harem of his successor. The philo-Asiatic politics of Amenhotep III were confirmed by yet another marriage, with the daughter of the king of the Kassites. The liveliness of relations between Egypt and Asia during the reign of this ruler and his successor has motivated several investigators to search for sources of the Amarna heresy, which approaches monotheism, in religious–philosophical concepts of Asiatic origin.

Although the harems of the kings of the Eighteenth Dynasty were filled with Egyptian and Asiatic women, the title of "great king's wife" was held by only one woman at a time. Even Kiya, a subordinate wife of Akhenaten for whom a palace and chapel were built, had to content herself with the title "wife and great beloved one"; she did not wear a crown and did not have her name inscribed in a cartouche. The designation "great king's wife" sometimes appears in inscriptions referring to the daughters of Akhenaten, which has led some scholars to suggest that this ruler had incestuous relations with his daughters. However, a more likely explanation is that, in this case, the title was purely honorary and served to elevate the rank of these princesses.

Queens occasionally assumed the office of pharaoh. This happened most often at the end of a dynasty, when the royal authority had been weakened or when the reigning pharaoh died prematurely or without issue. The first such instance known to us involved Nitokris (end of the Sixth Dynasty); a second, Sobeknofru (end of the Twelfth Dynasty); and a third, Tausret (end of the Nineteenth Dynasty). Although none of these queens held power for long, each of them attempted to resolve a difficult political situation and considered herself sufficiently strong to rule all of Egypt. However, when the death of the young Tutankhamen posed a similar threat to the Eighteenth Dynasty, Queen Ankh-es-en-pa-aton (later known as Ankh-es-en-amun, daughter and wife of Akhenaten, and later wife of Tutankhamen) did not place her trust in her own power but instead asked the Hittite king Shupululiumas to send her one of the Hittite princes as a husband. On the journey to Egypt, however, the prince, Zananza, was killed by unknown assassins, and Eye assumed power. The wife of the new ruler apparently also had an important role to play in political life, since she received the wife of a favored dignitary in a personal audience. During the rule of the subsequent (Nineteenth) dynasty, which

had its origins in the military, the "great king's wife" came to be over-shadowed completely by her husband. Beginning in the Third Interme-diate Period, the role of the queen became even less important—a fact that is linked significantly with the increasing prominence of the "god's wife of Amun," who was a woman of the royal clan.

Among the female regents who carried out the royal duties during the minority of a male heir to the throne, the greatest individuality was pos-sessed by Hatshepsut. The highest official at her court—the architect Senenmut, creator of the temple at Deir el-Bahari—may have also acted unofficially as her husband. In the art of the period, he is often repre-sented as the tutor of her daughter, the princess Nefrure. The last great woman ruler of Egypt, a female pharaoh of Greek origin, was the famous Cleopatra VII (69–30 B.C.E.), whose death ended the dynasty of the Ptolemies.

Unlike the Egyptian rulers (as well as several of the wealthiest magnates during times of decline of the central authority), the overwhelming ma-jority of Egyptian men led monogamous lives. This was not only the moral norm but also a necessity, since the contents of the marriage con-tract burdened the man with such considerable material obligations that, in most cases, their multiplication would have been impracticable. From a legal point of view, even the marriages of the majority of the pharaohs can be considered monogamous, since none of the women of the harem had the status of "great king's wife." To be sure, Egyptians of the lower social orders did not maintain harems; nevertheless, extramarital relations were more than isolated occurrences, although such affairs were consid-ered immoral from the standpoint of accepted ethical standards. Our in-formation on this subject derives from, on the one hand, a rich sapiential literature—that is, a literature of the written wisdom of the various peri-ods of Pharaonic civilization—and, on the other hand, the descriptions of specific cases contained in letters and judicial documents. The accounts of various classical authors constitute a valuable supplement to these sources, although their credibility must be verified by comparison with Egyptian documents. Many documents from the New Kingdom and the Late Period have survived.

Megalophallic man in a Greek tunic with a bundle of lettuce—the ancient Egyptian aphrodisiac—on his shoulder. Fragment of a terra cotta figurine. Ptolemaic Period, from the excavations at Tell Atrib.

The bull, symbol of potency

The Heliopolitan
sacred bull Mnevis
being worshipped by a
dignitary. Stele from
the period of the
New Kingdom.

Queen Hatshepsut in
the ritual running with
the bull. Relief at
Karnak.

Divine family in the Greco-Roman Period in Egypt. Fragments of ceramic vessels from Tell Atrib.

Head of Serapis in a relief
decorating a vessel.

Isis, Serapis, and Harpokrates.
Relief decoration of a ritual vessel.

The pharaoh in close contact with the goddess Hathor

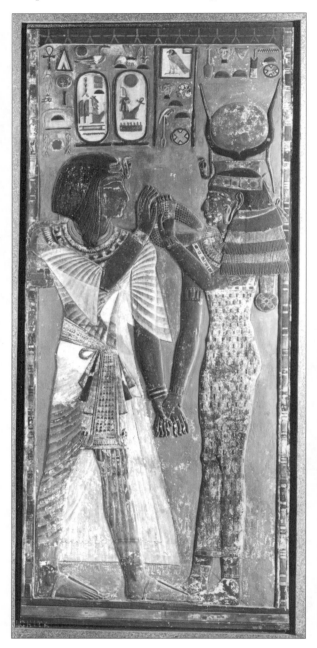

Seti I. Relief from the tomb of the ruler.

Shabaka. Relief in the temple at Luxor.

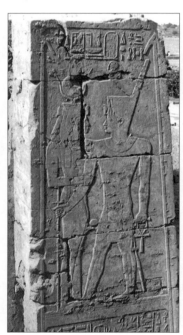

Rulers being breastfed by a goddess

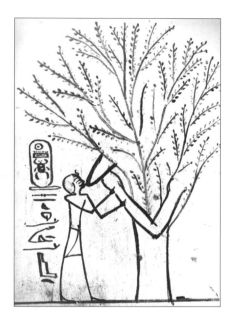

Hatshepsut sucking milk from the cow Hathor. Relief in the temple of Hatshepsut at Deir el-Bahari.

Thutmose III breastfeeding from a tree that personifies the goddess Isis. Painting in the tomb of Thutmose III.

Alabaster vessel used to hold oil that was rubbed onto the belly of a pregnant woman. New Kingdom.

Small jug in the shape of a wet nurse with a child on her lap. Clay vessel used to hold the milk of a nursing woman.

Queen Hatshepsut in close contact with the god Amun. Relief at Karnak.

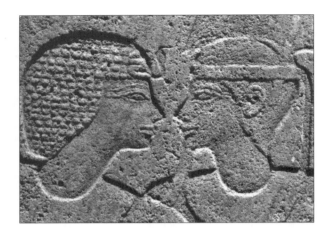

"God's wife of Amun" Ankh-nes-nefer-ib-re receiving the symbol of life from the goddess Isis. Relief at Karnak.

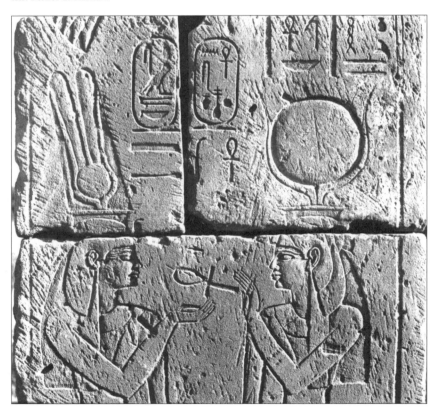

Breastfeeding goddesses

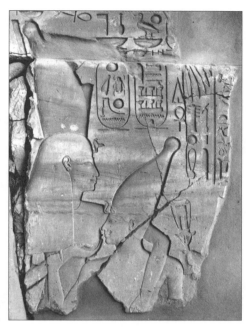

Mut suckling King Shoshenq I.
Relief at Karnak.

Hathor breastfeeding the young god Ihi in the company of Emperor Trajan, depicted as a pharaoh. Relief in the *mammisi* at Dendera.

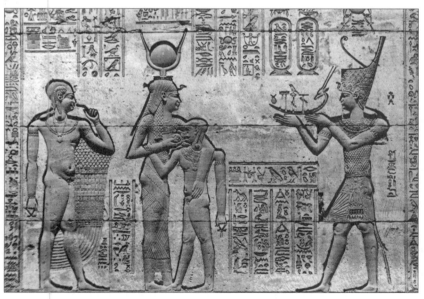

The erotic in the animal world. Terra cotta figurines of the Ptolemaic Period, from the excavations at Tell Atrib.

Pair of dogs.

Martial struggle of megalophallic frogs and mice.

5

Religion and Magic in Daily Life

THE IDEAL OF BEAUTY

Ancient Egypt was not a prudish society; nudity was considered one of the natural means of displaying the human body. Significantly more erotic, however—and also characteristic of ancient Egyptian culture—were female figures depicted wearing flowing, diaphanous garments, or else dressed in long frocks that clung to the body so tightly that their presence can be perceived only by the folds and edges of the fabric. Gowns often revealed a woman's breasts, while the obligatory canon representing the human form in relief made it possible to show a naked breast in profile even when, in reality, the wide shoulder straps should have covered it. The model of the human body, in sculpture, relief carvings, and paintings, emphasizes the roundness of the figures: The breasts are always vigorous and prominent, the belly slightly protuberant, the waist narrow and the hips wide, the thighs well developed, and the buttocks shapely. The bodies of anthropomorphic goddesses were represented in such a manner. However, the male sexual organ is emphasized only in representations of gods—in particular, of ithyphallic demiurges and guarantors of fertility. A notable exception is Bes, the protector of women in childbirth, who is also represented with an enlarged phallus.

The function of dress was not so much a prudish covering of the body

as an emphasis of social position. People without special status or of low social standing, as well as foreigners and deities of foreign origin, were shown naked. Images, therefore, show naked children (and the children of deities, such as Nefertum or Harpokrates), laborers and farmers at work, slain enemies, servants, and imported gods (Bes, for instance), represented according to the obligatory tradition in the place of their origin. Pharaohs are very seldom represented naked. Rare exceptions to this rule include an alabaster figurine of Pepi II (Sixth Dynasty) as well as the original representation of Akhenaten, in which the king is depicted without male sexual organs. Presumably, in the latter case, this depiction may be associated with the identification of the ruler with the bisexual creator-god. Among the deities of Egyptian origin, nudity characterized such guarantors of fertility as Nut, Geb, and Osiris. In the world of the gods, nudity emphasized fertility rather than eroticism.

Egyptian women wore a variety of items of personal adornment. In the upper strata of society, they commonly wore wigs—which were often sophisticated and were formed into a profusion of locks. Wigs were also worn by men, although men are often shown with clean-shaven heads, particularly when they are performing priestly functions. For civil servants, wigs were a symbol of social rank and were worn on various official occasions. A woman's head was sometimes adorned with a flower, a diadem, ribbons, a fibula, or earrings. Both men and women are frequently shown with their chests covered by a wide, elaborate necklace with multicolored elements of a variety of materials. Amulets were often components of these necklaces. Both men and women wore bracelets on their wrists and arms. The morning toilette of one of the ladies of the court of Mentuhotep (Eleventh Dynasty, Middle Kingdom) is even represented in relief on her stone sarcophagus. The occupant of the sarcophagus, a lady by the name of Kawit, is shown sitting on a throne, holding in one hand a small, exquisitely shaped mirror, and in the other a bowl containing a reviving drink. A male servant is filling the next bowl, while a female servant dresses the finely plaited locks on the head of her mistress.

Beauty was enhanced using an extensive stock of cosmetic agents, including paints, perfumes, oils, and creams. In the early historical periods, we see painted eyes, which were clearly intended initially for protection

from flies and excessive sun but later served an aesthetic purpose. Lead glance was used in paint and, as early as prehistoric times, was ground with grease on palettes that were specifically intended for this purpose. This raw material was extracted in Egypt, around Aswan and in the vicinity of the Red Sea, and was also imported, for example, from Punt and from the Asiatic Bedouins. Lead glance was also used in the treatment of eye diseases.

Medicines and magic were also enlisted in the service of female beauty. Surviving texts contain, among other items, recipes for preventing hair loss and graying, and for removing wrinkles or vermin from the surface of the skin. The most highly recommended substances were various secretions of the human body, and also of animals, now referred to as the Egyptian pharmacopoeia of filth. Other organic substances—primarily of vegetable origin—were also used. Oils such as olive oil were commonly employed in the daily toilettes of elegant Egyptian women. The hands and arms of guests were anointed with oil during visits, and a cone of grease mixed with aromatic substances was placed on their heads.

An element critical to creating a stimulating atmosphere was the alcoholic beverage, including various types of wine and beer. The use of alcoholic beverages, even in large quantities, was recommended as a means of arousing joy, and was sometimes even sanctified. Alcoholic beverages were consumed during different festivals honoring the gods, particularly those entrusted with the protection of physical pleasure, enjoyment, and fertility. The patroness of drunkenness, for example, was the goddess Hathor. At Dendera, the site of her cult, there was an annual festival of "sacred intoxication." Egyptian texts speak of drinking places, including taverns, but also sternly condemned any frequent resort to such places, the abuse of alcohol, the proliferation of prostitution by debauched women, and brawling by wandering drunks. Evidence of this growing problem is provided, for instance, by the admonitions of an elderly scribe to a young adept of the art of writing; he warns most distinctly against squandering time and neglecting one's studies in a search for pleasure. Libations often accompanied dancing and singing to the music of various instruments. Dancers with long, flowing manes of hair, wearing symbolic clothing, often performed acrobatic figures that emphasized their graces in a refined manner. In tombs today, one often encounters representations

of half-naked maidens executing a "little bridge" or else raising their legs high. During these performances musicians played harps, flutes, tambourines, and other instruments. A particular artistic attraction was the performance of a blind harpist playing hedonistic songs. Different versions of this text were recorded during the New Kingdom, among other places, on the walls of the tombs of noblemen. Here is a fragment of one of these texts:

> Hence rejoice in your heart!
> Forgetfulness profits you,
> Follow your heart as long as you live!
> Put myrrh on your head,
> Dress in fine linen,
> Anoint yourself with oils fit for a god.
> Heap up your joys,
> Let your heart not sink!
> Follow your heart and your happiness,
> Do the things on earth as your heart commands!
> When there comes to you that day of mourning,
> The Weary-hearted hears not their mourning,
> Wailing saves no man from the pit![1]

EROTICISM IN LYRIC POETRY

The lyrics of ancient Egypt provide a wealth of knowledge regarding Egyptian eroticism in the times of the pharaohs. The great majority of these verses—written sometimes on papyri, sometimes on ostraca, and occasionally on the walls of tombs—are from Thebes and date from the reigns of the Ramesside pharaohs (fourteenth–eleventh centuries B.C.E.). The content is full of passion but in an unusually subtle form, paying heed to decorum and restraint of modes of expression. The enamored one often speaks of an illness that is tormenting him, and which can be

[1] Harper's song from the tomb of Antef, preserved on Papyrus Harris 500, thirteenth century B.C.E.; M. Lichtheim, *Ancient Egyptian Literature: A Book of Readings*, vol. 1 (Berkeley, 1973), pp. 196–197.

cured only by the approach of the object of his desire; he is ready to pay the price and to make use of any ruse or wile. Here is the poetic confession of one enamored youth:

> I think I'll go home and lie very still,
> feigning terminal illness.
> Then the neighbors will all troop over to stare,
> my love, perhaps, among them.
> How she'll smile while the specialists
> Snarl in their teeth!—
> she perfectly well knows what ails me.[2]

Perverse reveries arise in his imagination:

> I wish I were her Nubian girl
> one to attend her (bosom companion),
> Confidante, and a child of discretion:
> Close hidden at nightfall we whisper
> As (modest by day) she offers
> Breasts like ripe berries to evening.[3]

A young girl, hurrying to a rendezvous with her beloved, has completely different worries:

> My heart remembers how I once loved you,
> as I sit with my hair half done,
> And I'm out running, looking for you,
> Searching for you with my hair down!
> If I ever get back, I'll weave
> An intricate hairdo down to my toes.[4]

[2] Song from the Papyrus Harris 500; J. L. Foster, *Love Songs of the New Kingdom* (New York, 1974), p. 72.
[3] Song from the Cairo Ostracon 25218; ibid., p. 28.
[4] Song from the Papyrus Harris 500; ibid., p. 112.

More sensual fragments describe sweet caresses:

> I strip you of your tangled garlands
> Once you are back again, O drunken man
> Sprawled deep in sleep (and gone) in bed.
> I stroke your feet
> While children . . .
>
> . . . cry out with wild longing.[5]

Or else they describe the maidenly graces:

> And the line of the long neck lovely, dropping
> (since song's notes slide that way)
> To young breasts firm in the bouncing light
> Which shimmers that blueshadowed sidefell of hair.
> And slim are those arms, overtoned with gold,
> Those fingers which touch like a brush of lotus.
> And (ah) the curve of her back slips gently
> By a whisper of waist to god's plenty below.
> (Such thighs as hers pass knowledge
> of loveliness known in the old days.)
> Dressed in the perfect flesh of woman
> (heart would run captive to such slim arms),
> she ladies it over the earth,
> Schooling the neck of each schoolboy male
> to swing on a swivel to see her move.
> (He who could hold that body tight
> would know at last
> perfection of delight—
> Best of the bullyboys,
> first among lovers.)
> Look, all you men, at that golden going,

[5] Song from the Papyrus Harris 500; J. L. Foster, *Love Songs of the New Kingdom* (New York, 1974), p. 38.

like our Lady of Love,
 without peer.[6]

Nowhere in these verses is there heard a vulgar or a pornographic note. Although the lovers refer to each another as "brother" and "sister," it is not appropriate to conclude from this that they were, in fact, brother and sister. The marriage of brothers and sisters was a common occurrence at the Egyptian royal court, but among people of the lower social order it was the exception rather than the rule.

Egyptian love poetry never speaks of marriage, or even of spouses, but only of lovers. The erotic sphere was held completely separate from the problematics of marriage, which, in Egypt, were associated rather with fertility and with legal questions regarding the material protection of each of the spouses and their children. In Egyptian texts, these two spheres overlapped only with a disturbance in the normal order of things—the infidelity of a spouse (in particular, of a wife), a divorce, or the various moral, material, and social consequences associated with such disturbances. Evidence of this fact is found in both legal and private documents (letters) as well as in several literary narratives.

Courtship, and aspirations to the conquest of the love partner, is often expressed in a delicate manner, particularly in poetry, mingled with a concern over sexual potency. It is true that the Egyptians believed in the potent force of magic; however, experience bade them also to help themselves in this regard using a variety of practical means: They prayed to gods renowned for their vital forces and made use of well-tested aphrodisiacs. The most commonly used "means of procreation" was a plant known as *mnhp*, which in Egyptian hieroglyphic writing ends with a sign (determinative) depicting a phallus. This plant, one of the ingredients of substances used for the "extraction of sperm," was linked, by magic, with the indefatigable vitality of Seth. Other vegetable aphrodisiacs included lettuce—the attribute of the ithyphallic Min—and mandrake (in Egyptian, *rrmt*). A similar effect was attributed to sperm (substituted for by the

[6] Song from Papyrus Chester Beatty I; ibid., pp. 45–47.

sap of plants) and to blood; these were the ingredients of love philters, and of ointments rubbed onto the male member.

EROTIC ART: THE TURIN PAPYRUS

Sexual relations between a man and a woman were depicted only rarely in Egyptian art. Such representations, which appear as figurines or as drawings in tombs and on ostraca, are either obscene or satirical in nature. An example of the latter is an illustration that details Egyptian concepts of sexual technique—the Turin Papyrus, which dates from the Nineteenth–Twentieth Dynasties and is currently housed in the Egyptian Museum in Turin. The papyrus, which is preserved, unfortunately, only in fragments, contains drawings that are designated in Egyptological literature as satiric-erotic. A portion of them comprise illustrations for humorous fables concerning animals that carry out various human activities and imitate human behavior—playing on musical instruments, attending a ritual banquet, even waging an armed attack on a fortress. However, the greater part of the papyrus consists of scenes of a sexual nature: the coupling of a man and a woman in various—generally sophisticated and highly improbable—positions, which were certainly not commonly practiced among the Egyptians.

It has been suggested that this document came into existence as a result of a military order, perhaps in response to the contemptuous attitude of scribes to soldiers, frequently encountered in Egyptian texts. It was likely intended to ridicule the priestly state through an amusing depiction of the coupling of a priestess with a slovenly looking man, who may also be in the service of the gods. While the female is represented here as shapely and elegant, her male partner is presented as short, dwarfish, nearly bald, and unshaven. He has a large head, a short neck, and an ugly face reminiscent of the muzzle of an ape, with a protruding jaw, a retreating forehead, and a hooked nose. Of note, however, is his enormous phallus, which, in some scenes, reaches to his ankles. In the majority of these scenes, the head of the woman is adorned with a lotus blossom, and she is wearing large earrings; she has a necklace draped over her breasts and wears bracelets on her upper arms and forearms, as well as a belt around her stomach. The male attire consists only of a short, triangular apron, which covers the back rather than the front of the body.

The entire set consists of twelve scenes; these are not separate from one

another or arranged in any logically developing sequence. Here, we describe these scenes, moving from the right to the left side of the papyrus, in the same direction as the reading of the hieratic writing in the accompanying inscriptions (which are also in very poor condition).

Scenes One and Two

The first scene represents *coitus a tergo*, carried out by a man standing on tiptoe and carrying a sack on his shoulders; the woman, who is significantly taller than he, is standing with her buttocks uppermost and is balancing herself on the tips of her fingers and toes. The next image is a group scene: A woman, sitting on the edge of a chariot, has her thighs visible behind the chariot and is turning her head to look behind her. The man engaged with her in *coitus a tergo* walks behind the chariot; he walks on tiptoe, pulling the woman's hair with his left hand, and in his right hand holding a small lute. On his right arm he bears a hoop-sistrum with a decoration in the form of the head of Hathor. The presence of these instruments suggests that this scene comprises the final episode of some sort of merry festival, complete with music and perhaps also libations. In this scene, exceptionally, the man is wearing a wig, which reaches down to his neck. The thill of the chariot is borne by two naked girls, who are being approached with an outstretched hand by a dwarfish

Erotic scenes (1 and 2) from the Turin Papyrus, Nineteenth–Twentieth Dynasty.

man with a disproportionately large, erect phallus. In his right hand, he carries a kind of bag with a handle; he is obviously trying to attract the attention of the young girls. This amusing scene is complemented by a monkey, which is jumping up onto the thill of the chariot. The type of sexual intercourse represented in this scene is referred to in Latin as *coitus anterior in situ posteriore*—one of the forms of *coitus a tergo*. It is appropriate to distinguish this act from anal relations.

Scenes Three and Four

In the next scene, the woman boldly takes the initiative, using her hand to encourage a man who is holding his hands up in a defensive gesture, while at the same time averting his head, as if attempting to tiptoe away. The woman sits on a round stool and raises her legs in a truly acrobatic position, while at the same time maintaining the vertical position of her torso and the immobility of her face. Her right hand guides the man's phallus between her thighs.

Equally acrobatic is the woman's position in the next scene. A beautiful naked woman sits at her toilette, with widely spread thighs, on the apex of a cone. This is probably a cone of aromatic ointment, of the type

Erotic scenes (3 to 5) from the Turin Papyrus, Nineteenth–Twentieth Dynasty.

usually placed on guests' heads during their visits. The woman, who is looking into a hand mirror, is making up her face with a brush-pencil, while an aroused man approaches her on his knees, touching her thigh with his right hand. The woman's face is turned away, suggesting that she is not paying any attention to her ithyphallic lover. The preserved polychromy of this scene makes it possible to distinguish the red of her vagina from the black of her pubic hair.

Scenes Five and Six

The next scene represents a position that is unusually difficult for both partners. A standing man slightly raises his left leg, bent at the knee, so that he can support on his thigh a sitting woman whose legs rest on his shoulders. Her vertical position is maintained by holding onto the man's head with one hand. The fact that the man stands only on the toes of his right foot does not hinder physiological activity. It is not surprising, however, that the next scene shows a weary male partner, lying below or alongside the bed of his female partner. Two jugs nearby suggest a state of alcoholic stupor—although not complete stupor, since his head is raised, and his erect penis indicates sexual readiness. His naked female partner, lying on a mattress, has one leg drawn up in a kneeling position and leans out from the bed, holding the man's head with both hands. Most likely, she wishes to help her partner up to join her on the bed.

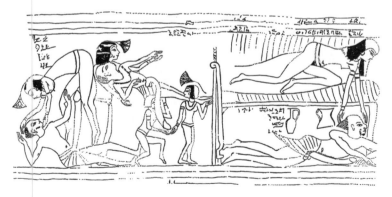

Erotic scenes (6 to 8) from the Turin Papyrus, Nineteenth–Twentieth Dynasty.

Scenes Seven to Nine

Continuing the motif of the exhaustion of the male vital forces, the next scene depicts a rigid male lover with a gigantic, but inertly dangling, member; the exhausted man is supported by three young women of different sizes. The tallest of the women bears his head on her shoulders; the shortest one holds his legs on her shoulders; the third one supports one of his thighs. The latter two women are touching, with their fingers, the drooping yellow male member. This carrying scene moves across a portion of the next scene, which shows sexual relations being performed in the positions of Geb and Nut, as known from paintings of mythological content. The man reclining on the ground—like Geb—is lifting his torso, supporting himself with his right hand on the ground, while his left hand spreads apart the woman's thighs, between which he guides his immense erect phallus. The female partner arches up her stooped body, like the arc of the sky goddess. Her feet rest on the man's thighs, while her hands embrace his head.

Near this scene of religious inspiration, we see yet another illustration of *coitus anterior in situ posteriore:* A bending woman leans with her hands on a stone, turning her head back, and the man, standing behind her on tiptoe, holds a lock of her hair in his left hand. The phallus of this man is markedly smaller than those in the previous scenes. As in the first scene, the male partner holds in his right hand a sack, which is draped over his left shoulder.

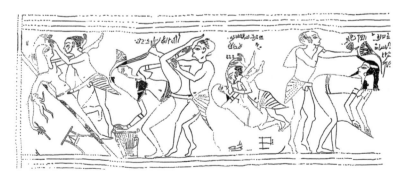

Erotic scenes (9 to 12) from the Turin Papyrus, Nineteenth–Twentieth Dynasty.

Scenes Ten to Twelve

The three remaining scenes represent different forms of relations in a frontal position—*coitus anterior*. In the first, a woman is coupling with a man in a half-lying position, raising her legs high and tucking them under her male partner's arms. Her left hand and his right hand are joined above the man's head. The penultimate scene presents a particularly striking position: The woman assumes an acrobatic stance, which corresponds with the positions of several female dancers represented in the act of carrying out their evolutions. She stands on her bent right leg and lifts her left leg sideways to reach the forehead of her male partner, who is standing. This position provides the male member access to the woman's vagina without any great physical effort. To maintain balance—his female partner's rather than his own—he holds her by the hair. Beneath the right hand of the woman there is a lyre, which may indicate a profession connected with music.

The last scene depicts sexual relations carried out on a slanted surface, and is reminiscent of the position of Osiris in several mythological scenes. A reclining woman rests her left leg on the man's shoulder, who in turn supports himself by resting his right knee on or between the woman's legs. With her left hand she draws the man's head toward her, while the left hand of the man touches the woman's face. This scene represents the phallus at its moment of entry into the vagina. The image, which completes the twelve-scene cycle, is situated on the margin of the papyrus and therefore constitutes an ironic parallel to scenes of the resurrection of Osiris, which occupy a similar position on the margins of papyri depicting mythological episodes. In the place of the god, and in his position, we find here the copulating woman. This parallelism may have been intended to suggest an analogy between the mummy of Osiris—the symbol of resurrection—and the sexual act, which ensures procreation. In other mythological images that conclude a cycle of scenes on papyri, the slanting element is the slope of a hill from which there emerges the cow's head of Hathor, the goddess of love.

The composition of the erotic portion of the Turin Papyrus, as well as its division into twelve scenes, clearly suggests an analogy with the *Book of*

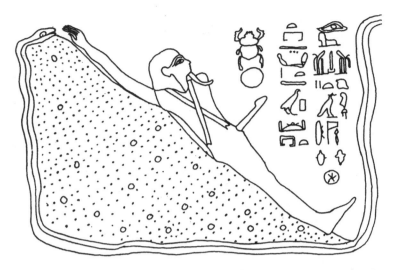

Resurrecting Osiris on the hill of Khepri. Painting from the Papyrus Hor-Uben B, Twenty-first Dynasty.

Amduat, which is known primarily from decorations in the royal tombs of the New Kingdom. There, the nightly migration of the sun god is represented in a set of twelve scenes that correspond to the twelve hours of the night. The entire work ends with a representation of Osiris, who also assumes the diagonal position, being resurrected. In the second hour, the Amduat speaks of the removal of the mummy bandages from the dead, while bandages are also the theme of the text that accompanies the second scene of the Turin Papyrus. Given these surprising analogies, it is possible that the Turin Papyrus was conceived as a satire on the cult of the dead, which was associated with the cult of royalty. The authors of the papyrus, by creating a work of such erotic content, were mocking the things that the Egyptians held most sacred. This view is supported by several other details. It is true that one pair of lovers assumes the position of the mythological Geb and Nut, but the female partner is shown tickling the chin of the male partner. Also, in the first scene, the position of the woman is similar to that of the sky goddess, but the position of her hands mirrors exactly those of the damned in the underworld, as represented in

mythological scenes. The woman who is shown coupling on the edge of a war chariot with a man who is walking behind it represents none other than an Egyptian *militia Veneris*: She plays the role of the winner, while he is the loser. The young girls pulling the chariot also appear to constitute a well-conceived mockery, considering that the Egyptian word for girl (*nfr*) is written similarly to the word for horse; the images of these girls thus form a kind of hieroglyphic for the word *horse*.

In the central scene, the legs of the man lying below the bed have a position reminiscent of both the deceased Osiris and the floating corpse of a (Hittite) enemy. The arousal of an exhausted male partner by a woman is a clear allusion to the roles of the deceased Osiris and of Isis, as she hovers over him in the form of a bird. The man defending himself from relations with a woman may recall the misogynous primeval god, while the woman's hand guiding the phallus into her vagina may be associated with the "hand of the god"—which, it is true, was that of a male god in Heliopolitan myth but was later identified with various goddesses.

The bisexual primeval god could also be a female deity. The warrior goddess Neith, for instance, is depicted with a shield and holds arrows in her hands; beginning in the Late Period, she was identified with the Greek goddess Athena. Another representation identifying the "hand of the god" with women is seen in votive figures of the Greco-Roman Period, which show a woman's palm holding a phallus with a bared tip. Figures of this type, made of marble, were found during the Polish excavations in Alexandria.

The Egyptian family in statuary sculpture

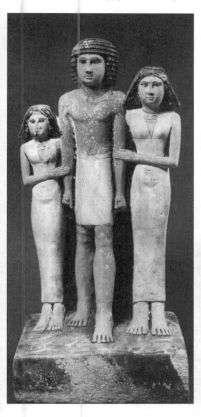

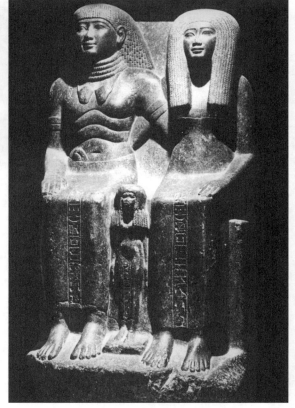

Sennefer, mayor of Thebes, with his wife and daughter. New Kingdom.

Statue of a father with his two daughters. Fifth Dynasty.

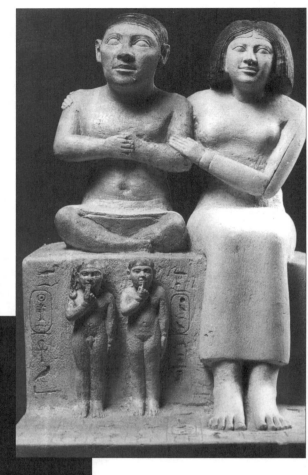

Statue of the dwarf Seneb and his family. Old Kingdom.

Princess Nefrure, daughter of Hatshepsut, being embraced by Senenmut, her tutor. Statue from Karnak.

The Egyptian family. Scenes in reliefs on funerary stelae.

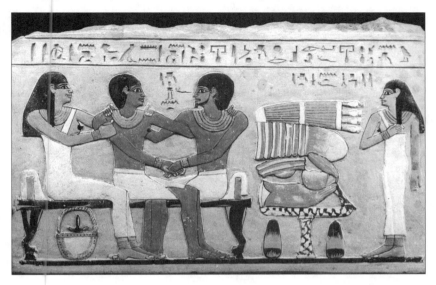

Son being embraced by his deceased father and his wife. Stele from the Middle Kingdom.

Deceased man with his wife. New Kingdom.

Egyptian marriage in the afterlife. Reliefs from the walls of tombs, New Kingdom.

Musical instruments
in the erotic sphere

Queen Nefertari, wife of
Ramesses II, offering the
goddess Hathor sistra (rattles)
in the shape of Hathor's
head. Relief in the temple at
Abu Simbel.

Clappers in the shape of the
hand of the primordial god, as-
sociated with his creative act.
Ivory instruments.

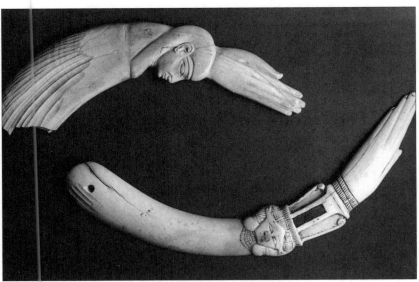

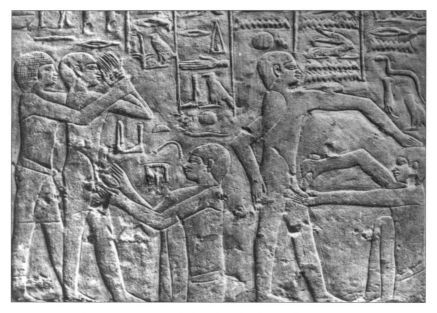

Circumcision of a young man. Bas-relief on the wall of a tomb at Saqqara, Old Kingdom.

King Ahmose with his "great king's wife" and his eldest son, receiving the symbols of life and stability from the god Amun-Re. Relief at Karnak.

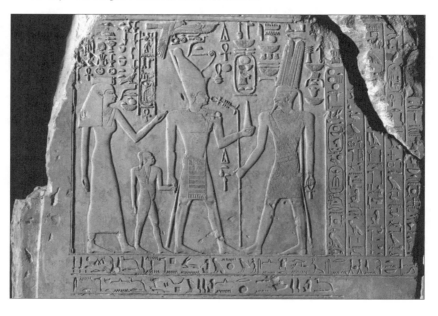

The harp, an instrument associated with the joys of life

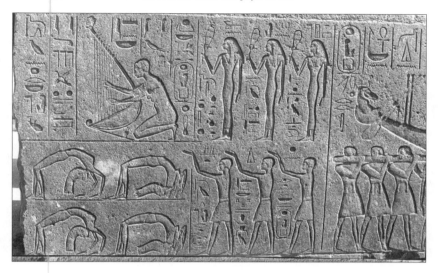

Harpist, musicians, dancers, and singers. Relief from a temple of Hatshepsut at Karnak.

Young female harpist with the god Dionysus(?). Fragment of a terra cotta figurine. Ptolemaic Period, from the excavations at Tell Atrib.

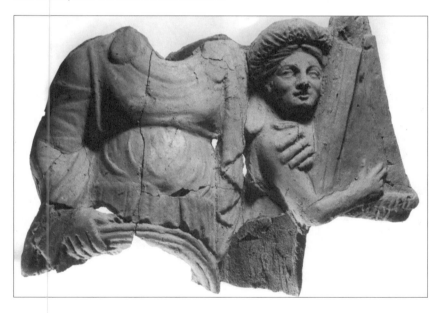

6

Sexual Life: Standards and Constraints

As in the case of lyric poetry, the drawings on the Turin Papyrus represent the Egyptian woman as an exacting, self-willed partner, with a strong sense of independence, and, in sexual matters, clearly dominating the male. The male penis depicted in the papyrus is circumcised, which was the norm for Egyptian men during the period of the New Kingdom. Only during the Late Period, perhaps as a result of the intermingling of the Egyptians with other peoples (such as Libyans, who were not circumcised), does there begin the emphasis on circumcision as a condition for ritual purity, particularly for priests.

However the contents of the Turin Papyrus are interpreted, they are not likely to lead to any far-reaching conclusions regarding Egyptian sexual practices or the ethos of Egyptians' sexual lives. Our information in this area comes primarily from written sources, which, in many cases, advise a far-reaching sexual moderation. The sapiential literature of ancient Egypt contains warnings against reckless contact with women, as well as severe condemnations of acts of debauchery committed with dissolute women. Egyptian men were taught respect for women and a restriction of "sexual acquaintance" to marital cohabitation; women were enjoined to exercise a fitting dignity and to prepare themselves well for their maternal duties. In regard to virtuous conduct, Egyptian moral standards de-

manded more from the woman than from the man, with the primary focus being the legitimacy of progeny.

Sexual temperance, considered a precondition of ritual purity, is associated particularly with priests and priestesses, in keeping with the provisions of the religious calendar. Sexual abstinence was required of the weepers who assumed the roles of Isis and Nephthys, while lifelong virginity was compulsory for the "god's wives of Amun" from the Third Intermediate Period on. The priests of Apis at Memphis apparently were also forbidden to engage in sexual relations. On the other hand, all Egyptians were prohibited from having sexual intercourse on those days when, according to the religious calendar, the gods were engaging in sexual relations. According to the account of Diodorus, these periods of sexual restraint also included the seventy-two days of mourning that followed the death of a pharaoh. Herodotus informs us that before entering a temple, even those people not involved in priestly functions had to wash themselves after sexual intercourse.

However, Egyptian lads did not have to curb their sexual impulses for long, since marriages were generally made on reaching maturity, at twelve to thirteen years of age. Marriage was not a religious, civil, or legal act, but rather a social fact, defined by universally binding custom. Although we have no detailed accounts of the wedding ceremony itself, we nevertheless know that, in the interests of both spouses, written agreements were drawn up; these marriage contracts were primarily concerned with the establishment of property rights, an area in which there were at the time no specific regulations. The marriage contract constituted an act of free will by the marriage partners, and was often drawn up only in the course of the marriage. This agreement assumed particular importance in cases of divorce, when it became necessary to parcel out the marital property, and it took into consideration above all the well-being of the wife and children. The marriage contract was recorded by a scribe, in the presence of witnesses. The oldest surviving marriage contract dates from the Late Period (seventh to sixth centuries B.C.E.).

FERTILITY AND CHILDBIRTH, MAGIC AND MEDICINE

The goal of marriage was procreating and raising children. In carrying out this role, the Egyptians were assisted by both medicine and magic,

which together created a single, highly developed sphere of knowledge. The maintaining of sexual potency and fertility was a subject of particular importance for the Egyptians. The aphrodisiacs referred to in chapter 5 were considered effective in this role, as were various magical figurines. These figurines, which were most often made of clay, appeared as early as the Predynastic Period. They were used to safeguard the entire sphere of sexual activities—above all, the procreative functions. The oldest of these, which is associated with the Badari culture (probably the oldest agrarian culture in the Nile Delta region), may date from as early as the end of the sixth millennium B.C.E.; these figurines have the form of naked women with their hands held under their breasts. They are distinct from the so-called "dancer" statuettes, which are characterized by their uplifted arms and are associated with the Nagada culture (Upper Egypt, fourth millennium B.C.E.). In later times, there were figurines depicting a woman lying naked on a bed; in these, the primitive modeling of the body stands in sharp contrast to the clear, careful delineation of the sexual features. The female sexual organ is shown as a large triangle, with incisions simulating pubic hair; the vagina is visible, and the breasts are carefully modeled and shapely. Figurines representing a woman with a child on her lap or in her arms, often in the act of suckling the child, played a similar magical role for birth mothers and wet nurses. Undoubtedly, the votive function, associated with the desire to ensure fertility and successful childbirth, was also fulfilled by the erotic figurines from Tell Atrib, which were particularly numerous in the vicinity of the unearthed structures of the public baths.

In addition to these various methods for ensuring fertility, there were also certain practices used to prevent unwanted pregnancies. They were employed typically by women of the higher strata of Egyptian society. A medical papyrus dating from the time of the Middle Kingdom, found at Kahun, contains recipes comprising a combination of practical knowledge and magic. They recommend, for example, insertion into the vagina of crocodile dung, honey, or resin. The use of dung in a prophylactic role is also referred to in a significantly later papyrus, from the reign of Ramesses IV. The Papyrus Ebers, which dates from the time of the New Kingdom, provides a recipe for an intravaginal compound made from the tips of acacia twigs (which contain gum arabic), dates, and honey, admin-

istered on a bit of woolen fabric. The action of this mixture was, doubtless, supposed to be both physical and chemical in nature.

Infertility was considered a great misfortune, and all possible measures were taken for its prevention. To determine whether a woman was sterile, her vagina was fumigated and the effect of her urine on grains of wheat and barley was observed. The latter method was also apparently used to determine whether a woman was pregnant, and if so, the sex of the expected child. The hope of every marriage was to produce male progeny; the son could attend to the funerary rites and participate in the posthumous cult of his father. The lack of a son, then, was a cause for grief within the family. The living prayed to the dead to receive male issue, because the deceased were identified with Osiris, the guarantor of fertility. Related prayers were written on magical scarabs. In the Late Period, prayers for this purpose were made to the deified Imhotep, the sage from the beginning of the Third Dynasty, and the architect of the pyramid of Djoser.

Medical methods were also used to determine whether a woman was pregnant; particular attention was paid to the condition of the breasts and the color of the skin. Clinical methods were also known. Vomiting was regarded as a positive sign for pregnancy. The childbearing organs were inspected as high up as the neck of the uterus. Although it was thought that the vagina could be penetrated as high up as the stomach, surgical procedures were not performed; the Egyptians used only washing, fumigation, and pessaries. Other recommended gynecological specifics included beer, milk, dates, herbs, and the various discharges—substances that made up the Egyptian "pharmacopoeia of filth."

The Egyptians were well aware of the relationship between menstruation and pregnancy, as well as the duration of pregnancy, which was considered to be ten months. During their pregnancies, women were attended with particular care and were entrusted to the protection of the responsible deities, such as Bes (described in chapter 2) and the goddess Thoeris. The latter is represented as a pregnant hippopotamus with the head of a crocodile, the paws of a lion, and human palms. The characteristic attribute of Thoeris was a papyrus-stalk loop, which in Egypt functioned as a life-saving belt. Thoeris was considered to be the protectress of women in childbirth and of breastfeeding mothers. She was also as-

cribed the role of wet nurse, which was generalized into that of female provider. She was a patroness of apotropaic significance during nuptials and childbirth. Because of this, Thoeris also assisted at the mythical rebirth—that is, the sunrise.

Images of Thoeris adorned objects such as chairs, beds, and headrests. Small bottles, made of alabaster and having a shape midway between that of a pregnant woman and a pregnant Thoeris, were a special type of vessel associated with the protection of pregnant women. Today they are referred to simply as "bottles of the pregnant." The shape of the body, which was naked, and in particular the clumsy, widely spaced, short legs and pendulous breasts, is reminiscent of the hippopotamus goddess, although the face, with the features of an ugly woman, is often twisted, as if in pain. The hair is pulled back smoothly and plaited. Characteristic features of this figure are the position of the palm on the belly, in a rubbing gesture, and the total absence of any indication of a sexual orifice. In some instances, Thoeris is represented holding the horn of an animal in her hand. These vessels were likely used as containers for medicine that was rubbed onto the bellies of pregnant women; this ointment was used to prevent the appearance of ridges and marks, particularly during the final stages of pregnancy. Small animal horns were used in Egypt as containers for oil, which was most likely mixed with the contents of the alabaster container to make the ointment easier to rub onto skin. These alabaster vessels in the shape of the goddess Thoeris would certainly have been found in any good Egyptian medicine chest. On the other hand, clay vessels decorated with a likeness of the head of Bes were used to hold milk that was offered in the ritual purification of the dead.

To safeguard against the loss of a child, the vaginas of pregnant women were often sealed. Egyptian women tried to prevent miscarriages with the use of tampons, knots, bands, and plugs. The plugging of the uterus with a tampon was also intended to prevent hemorrhaging (the so-called blood of Isis). Attempts were also made to drive away any forces that could harm a pregnant woman or her child. The woman's hair was bound tightly, thereby binding the evil demons, and while the hair was being bound up, a magic spell was recited.

Egyptian women gave birth in a sitting, squatting, or kneeling position. Because women in childbirth were considered to be impure, when the

time of birth was imminent, they were led out from the house to a small bower set up in the courtyard or garden. The woman sat on a crude birthing chair that was made of brick or stone arranged in columns. She was given an analgesic drink to help soothe any pain. Midwives assisted at the delivery, and cephalic delivery was the norm. After the delivery, the umbilical cord was cut, the infant was washed, and the afterbirth was examined to determine the child's chances of survival. Other observations were also used to make this prediction: the first sounds made by the infant, its manner of holding its head, or its response to an offered preparation consisting of a mixture of its own afterbirth and milk. The patroness of all birth-related activities was the goddess Meskhenet, whose name derives from the Egyptian substantive noun *mshnt*—that is, "delivery" or "going out." She was considered to be the deity personifying the birthing bricks, or birthing places in general, and was represented as a squatting woman with the head of a baby emerging from between her thighs. This was also the shape of the hieroglyphic sign for the Egyptian word *mesi*—"to give birth." Meskhenet was represented with the symbol of a cow's uterus on her head. As the divine mother she determined the fate of the child, sharing this role with the seven goddesses named Hathor, who assumed this role from the time of the New Kingdom.

In spite of the use of a variety of medicinal and magical aids, many women and infants died during childbirth. Evidence of this comes from the numerous mummies of babies and their mothers. Mothers died of various types of birth complication, such as uterine dysfunction or hemorrhaging, while infants most often died of catarrh of the stomach and intestines. The same sources indicate that "monsters"—severely retarded or hydrocephalic children—were sometimes born. It was believed that various threats extended even to childbearing goddesses and their offspring; mythology therefore ascribes to various deities the task of safeguarding both the personified divine mother, Isis, and her son, Horus. These motifs from the myths about Isis and Horus were in turn used in apotropaic magic, applied at the birth of earthly beings—for example, in the form of numerous amulets.

One of these amulets, known as the "knot of Isis," was made of red jasper or carnelian. It had the form of a stylized tampon or band of the mother of Horus and was used to plug her vagina, preventing her from

hemorrhaging (the "blood of Isis") or having a miscarriage. In the *Coffin Texts*, the danger threatening the pregnant goddess is defined as the possible destruction of the embryo by the enemy (that is, by Seth). For this reason, (Re-)Atum tied a protective cover "inside the vagina of Isis." One section of the *Book of the Dead* contains these words, directed to Isis: "Your blood belongs to you, O Isis." The Egyptian word for "knot of Isis" (*tjt*) is derived from the word signifying a cover or veil. Amulets of this shape became the symbol of life and rebirth.

Wealthy Egyptian women engaged wet nurses for their newborn infants; however, the majority of Egyptian women had to breastfeed their own children from the time of birth to the age of three. Breastfeeding was also regarded as a good method for preventing subsequent pregnancies. Goddesses were sometimes represented in the role of wet nurse, particularly in the case of royal children. From the time of the New Kingdom this role was often played by Renenutet, patron goddess of bountiful harvests. She is represented as either a snake or a woman with the head of a snake, breastfeeding a divine child named Nepri, who personified wheat or grain. During the Greco-Roman Period, Renenutet, who is frequently identified with other female guardians of fertility and birth, was associated with Isis suckling Horus. (Isis is also represented in numerous votive figures.) The Greek name for the Egyptian goddess of bountiful harvests, Thermuthis, still appears in Christian-era texts as the name of the daughter of a pharaoh; she raised Moses and was sometimes considered to be a saint.

Mother's milk was one of the most popular medicinal substances in Egypt. Its uses extended far beyond the areas of gynecology and obstetrics to the treatment of colds; diseases of the eye, ear, and skin; eczema; furuncles; hemorrhaging; burns; and bed wetting; it was also used as a pregnancy test. Infants were given medicines mixed with mother's milk. Owing to its wide range of uses, mother's milk—and in particular, wet nurse's milk—was collected and preserved in special clay (or more rarely, steatite) vessels whose capacity corresponded to the amount of milk produced by a woman's breast ($102-140$ cm^3).

These small vessels, which were twelve to thirteen centimeters high, were distinguished above all by their characteristic form—that of a squatting wet nurse with a child, no longer an infant, playing on her lap. The

upper part of the jug consists of a funnel, whose size and shape indicate that it was applied directly to the nipple. The wet nurse, clad in a simple, loose-fitting garment, has one hand laid on her breast, in a manner suggesting that she is squeezing out milk. Her other hand sometimes holds an animal horn with a shape similar to that of an oil container, which is known to us from the iconography as the "bottle for pregnant women." Mother's milk was sometimes mixed with oil, for medicinal purposes. However, the presence of this object in the iconography of the wet nurse may also be an indication that—in accordance with known recipes of ancient Egypt—after the issuance of milk, the woman's spine was rubbed with an olive to hasten the secretion of the next portion of milk. In contrast to these alabaster "bottles," which represent a future mother with her hair bound up on the back of her head, the small milk jug represents a woman with unbound hair, who is wearing a moon-shaped amulet over her breasts. The apotropaic significance of this amulet was undoubtedly associated with the frequently changing form and contents of the breasts of wet nurses, since for Egyptians the moon had an association with constant changes, appearance, and disappearance.

Regarding the health of children in ancient Egypt, paleomedical research indicates the existence of numerous pelvic anomalies but relatively few cases of rickets. Although it cannot be determined precisely at what age a child underwent circumcision, the ritual is represented in one of the tombs of the Old Kingdom. Indirect sources indicate that the circumcision ceremony took place close to the age of sexual maturity, between the ages of ten and twelve. The mummy of a ten- or eleven-year-old prince, however, shows no traces of circumcision. Perhaps circumcision of the phallus marked the passage from boyhood to manhood. Although circumcision is a type of surgical procedure, it is not mentioned in any ancient medical texts. The circumcision scene just referred to, depicted in the tomb of Ankh-ma-hor (Sixth Dynasty) at Saqqara, shows a priest squatting in front of a youth who is undergoing the procedure and is being held by an assistant. The priest is using an oval surgical instrument—perhaps made of flint, the traditional ritual tool. The next scene shows the phallus being rubbed, either prior to the operation, for anaesthesia, or afterward, for dressing the wound. Circumcision, which has been traced back to prehistoric times, was not restricted to any particular

social stratum. Not until the Late Period did it become a condition for performing priestly functions. Probably only at this time did circumcision take on significance in terms of cult purity. Among the foreign people living in Egypt, the Libyans were regarded as uncircumcised; however, the so-called Sea Peoples, who appeared in Egypt during the reigns of the Ramesses, are known to have practiced this custom. Although we have no direct information regarding the circumcision of girls, there are references in some Egyptian texts to "uncircumcised virgins."

MARRIAGE AND DIVORCE

In marital matters, the Egyptian woman was an equal partner of the man; she was able to make decisions concerning her own fate, to impose conditions on her husband, and even to prevail over her husband regarding property and social position. We know from written sources, for example, the case of a wealthy woman whose husband was a common soldier. Some women married several times, choosing their husbands from among the representatives of different races and professions. Information survives regarding one Egyptian woman who first married a scribe and then an artisan. Egyptian wisdom recommended, on the one hand, that the male candidate for marriage should find employment, get on in the world, and achieve suitable means and recognition before being united with a woman, and, on the other hand, that he should marry young ("when he is twenty") so that he should have a son "while he is still young himself."

On the higher rungs of the social ladder, there were often marriages between closely related people. Their mythological prototypes were the unions of brothers and sisters—Osiris with Isis, and Seth with Nephthys. Marriages between brother and sister were common in the court of the Ptolemies, and such unions also occurred in the royal family in pharaonic times. To maintain the purity of their blood, kings also married their own daughters. Both Amenhotep III and Ramesses II made marriages of this type; the latter ruler married three of his daughters. Among the lower social orders, there were numerous instances of marriages between slightly more distant relatives—between half brothers and half sisters, cousins, and an uncle and a niece, for example. Nothing is known re-

garding the bonds that united couples of restricted legal status. Presumably, the union of two slaves simply consisted of cohabitation. A female slave could cohabit with two free married people and could become a concubine of the master of the house, particularly in cases in which the legitimate wife was unable to bear children. However, the progeny of a slave and the master of a house retained the legal status of the mother. Only the offspring of two free people were considered to be freeborn.

It happened that marriage contracts specified a limited period of time, as sources of the Ptolemaic Period indicate. One of these marriage contracts details the conditions agreed to by a gooseherd for a period of nine months, after which time his wife was suitably rewarded. It is not known whether this man concerned himself with verification of the fertility of his wife prior to making a decision about a permanent union, or if he was not in a position to maintain a family for an extended time.

One essential element in the making of marriages was the virginity of the bride-to-be. Maidenly virtue was regarded as a definite, tangible asset, for which a wife was to be rewarded materially by her husband, particularly in cases of divorce. A woman who married as a virgin received from her husband the so-called maiden's gift. Marriage was considered an institution in which an exchange of services was carried out by the marital partners. The woman ensured the man a regular sexual life, and he in turn was charged with the support of the family and the transferral of property, protecting his inheritance for his progeny. To safeguard her good name in the community, a married woman would insist on an agreement that specified her legal and material marital position. Surviving contracts of this type concern the question of the division of goods and inheritance in the case of divorce (*separatio bonorum*). Some of these marriage contracts were recorded only after a permanent union had been established. In such cases, the husband and wife were termed "brother" and "sister," emphasizing the equality of their partnership.

Marital infidelity and divorce are attested to both in Egyptian legal documents and in belles-lettres. The instigator of the breakup of a marriage was generally the woman, who, in matters relating to marital ethics, was judged more severely than the man. One literary incarnation of an unfaithful wife is the spouse of Anup, the elder brother in the Tale of the Two Brothers, written near the end of the Nineteenth Dynasty in the Pa-

pyrus d'Orbinay. She had attempted, with all her wiles, to seduce the younger brother, Bat:

> And she desired to know him as a man. She got up, took hold of him, and said to him: "Come, let us spend an hour lying together. It will be good for you. And I will make fine clothes for you. . . ."
>
> Then the youth became like a leopard in his anger over the wicked speech she had made to him; and she became very frightened. He rebuked her, saying: "Look, you are like a mother to me; and your husband is like a father to me. He who is older than I has raised me. What is this great wrong you said to me? Do not say it to me again! But I will not tell it to anyone. I will not let it come from my mouth to any man." He picked up his load; he went off to the field.[1]

Frustrated by her failure, stricken with fear in the presence of her husband, the unfaithful wife shammed illness and placed the blame on the younger brother, accusing him before Anup:

> "No one has had words with me except your young brother. When he came to take seed to you, he found me sitting alone. He said to me: 'Come, let us spend an hour lying together; loosen your braids.' So he said to me. But I would not listen to him. 'Am I not your mother? Is your elder brother not like a father to you?' So I said to him. He became frightened and he beat (me), so as to prevent me from telling you. Now if you let him live, I shall die! Look, when he returns, do [not let him live]! For I am ill from this evil design which he was about to carry out in the morning."[2]

However, after many dramatic reversals, the truth was discovered, and the faithless wife was accorded a well-deserved punishment. Her husband killed her and then cast out her body to be devoured by dogs. This tale is the archetype of the biblical account of the wife of Potiphar, who seduced Joseph.

[1] From the "Tale of the Two Brothers"; M. Lichtheim, *Ancient Egyptian Literature: A Book of Readings*, vol. 2 (Berkeley, 1976), pp. 204–205.
[2] From the "Tale of the Two Brothers"; ibid., p. 205.

Egyptian literature frequently condemns not only the treachery of a wife, but also seduction by a man. The text of one papyrus contains a reproach directed at a man who raped other men's wives; in another instance, a wife accuses her husband—probably in court—of committing adultery. A text preserved on an ostracon contains an oath sworn by a man who asserts that he has had no sexual relations with a certain woman. Among the papyri from the New Kingdom found at Deir el-Medina is a document that informs us of the punishments that threatened the lover of a married woman. A complaint was brought before the court by an outraged husband who had caught his wife engaging in extramarital relations. The seducer had to swear that he would renounce all intimate contact with the woman in question; otherwise, he was threatened with having his nose or ear cut off or even being deported to Nubia. When the immoral act was repeated, however, the lover was brought once more before the court and made to swear an oath. This time, he was faced with banishment to the quarries at Elephantine; it is not known what punishment, if any, was meted out to the unfaithful wives in such cases. Numerous oaths recorded in Egyptian temples during the Late Period provide evidence that women whose reputations were threatened had to swear to the gods that they had not had relations with anyone except their husbands since the beginning of their marriage. At present, no evidence exists of whether men had to swear similar oaths.

Marriages ended either with the death of one of the spouses or through divorce. As in the case of drawing up the marriage contract, divorce was a purely private matter, devoid of civil or religious aspects. Reasons for a divorce might be the adultery or infertility of the wife, a significant fault in one of the partners that the other partner found intolerable, or else, commonly, a loss of affection on the part of one of the spouses and the desire to enter into marriage with another person. The party who acknowledged that there were sufficient grounds for divorce was the husband. Although there was complete freedom to divorce, the divorcing of a married couple without substantial cause met with social condemnation. In cases of divorce, the husband provided the wife with evidence verifying that he renounced all claims to her and was granting her the freedom to remarry. Documents of this type have been found dating back to the fourth century B.C.E. Divorced women most often left

the home. The material claims of women vis-à-vis their former husbands could be made even after the divorce. As a result, the breakup of a marriage ruined some men, while in many cases it substantially improved the material situation of women. The majority of Egyptian marriages were, however, long-lasting, upholding the high ethical standards prescribed in the contemporary wisdom literature.

Egyptian wisdom of all periods favored marriage as, among other things, an institution that provided protection against debauchery; it also severely condemned unarranged, hasty compliance with one's own libido. Here is advice on this subject from the "Instruction of Ani," which dates from the Eighteenth Dynasty and is known to us from later copies (Ramesside Period):

> Beware of a woman who is a stranger,
> One not known in her town;
> Don't stare ar her when she goes by,
> Do not know her carnally.
> A deep water whose course is unknown,
> Such is a woman away from her husband.
> "I am pretty," she tells you daily,
> When she has no witnesses;
> She is ready to ensnare you,
> A great deadly crime when it is heard.[3]

The conclusion is as follows:

> Do not go after a woman,
> Let her not steal your heart.[4]

Considerably earlier, during the reign of King Djedkare (Fifth Dynasty), the old vizier Ptahhotep recorded the following counsel for his "son"

[3] From the "Instruction of Ani"; M. Lichtheim, *Ancient Egyptian Literature: A Book of Readings*, vol. 2 (Berkeley, 1976), p. 137.
[4] From the "Instruction of Ani"; ibid., p. 143.

Fifth Dynasty (ca. 2494–2345)
 Userkaf
 Sahure
 Neferirkare
 Shepseskare
 Niuserre
 Djedkare
 Unas
Sixth Dynasty (ca. 2345–2181)
 Teti
 Userkare
 Pepy I
 Merenre
 Pepy II

First Intermediate Period (ca.
 2181–2133)
Seventh–Tenth Dynasties

Middle Kingdom (ca. 2133–1786)
Eleventh Dynasty (ca. 2133–1991)
 Antef I–III
 Mentuhotep I–III
Twelfth Dynasty (ca. 1991–1786)
 Amenemhet I (ca. 1991–1962)
 Senusret I (ca. 1971–1928)
 Amenemhet II (ca. 1929–1895)
 Senusret II (ca. 1897–1878)
 Senusret III (ca. 1878–1843)
 Amenemhet III (ca. 1842–1797)
 Amenemhet IV (ca. 1798–1790)
 Neferusobek (ca. 1789–1786)

Second Intermediate Period (ca.
 1786–1567)
Thirteenth to Fourteenth Dynasties
Fifteenth to Sixteenth Dynasties: Hyksos
 Kings
 Apophis I, Apophis II, and others
Seventeenth Dynasty: Last Rulers
 Sekenenre
 Kamose

New Kingdom (ca. 1567–1085)
Eighteenth Dynasty (ca. 1567–1320)
 Ahmose (ca. 1570–1546)
 Amenhotep I (ca. 1546–1526)
 Thutmose I (ca. 1525–1512)
 Thutmose II (ca. 1512–1504)
 Hatshepsut (ca. 1503–1482)

 Thutmose III (ca. 1504–1450)
 Amenhotep II (ca. 1450–1425)
 Thutmose IV (ca. 1425–1417)
 Amenhotep III (ca. 1417–1379)
 Amenhotep IV/Akhenaten (ca.
 1379–1362)
 Smenkhkare (ca. 1364–1361)
 Tutankhamen (ca. 1361–1352)
 Eye (ca. 1352–1348)
 Horemheb (ca. 1348–1320)
Nineteenth Dynasty (ca. 1320–1200)
 Ramesses I (ca. 1320–1318)
 Seti I (ca. 1318–1304)
 Ramesses II (ca. 1304–1237)
 Merenptah (ca. 1236–1223)
 Amenmesse (ca. 1222–1217)
 Seti II (ca. 1216–1210)
Twentieth Dynasty (ca. 1200–1085)
 Setnakht (ca. 1200–1198)
 Ramesses III (ca. 1198–1166)
 Ramesses IV (ca. 1166–1160)
 Ramesses V (ca. 1160–1156)
 Ramesses VI (ca. 1156–1148)
 Ramesses VII and Ramesses VIII (ca.
 1148–1140)
 Ramesses IX (ca. 1140–1123)
 Ramesses X (ca. 1123–1114)
 Ramesses XI (ca. 1114–1085)

Third Intermediate Period (ca. 1085–656)
Twenty-first Dynasty (ca. 1085–945)
 Capital at Tanis
 Some rulers include:
 Smendes
 Psusennes I
 Amenemope
 Siamun
 Psusennes II
 Capital at Thebes; High Priests of
 Amun rule
 Some High Priests include:
 Pinodjem I
 Masaharta
 Menkheperre
 Smendes II
 Pinodjem II
 Psusennes III
Twenty-second (Libyan) Dynasty (ca.
 945–715); capital at Bubastis
 Shoshenq I (ca. 945–924)

Osorkon I (ca. 924–889)
Shoshenq II (ca. 890)
Takelot I (ca. 889–874)
Osorkon II (ca. 874–850)
Harsiese (ca. 870–860)
Takelot II (ca. 850–825)
Shoshenq III (ca. 825–773)
Pami (ca. 773–767)
Shoshenq V (ca. 767–730)
Osorkon IV (ca. 730–715)
Twenty-third Dynasty (818–715)
Pedubaste I (ca. 818–793)
Iuput I (ca. 804–783)
Shoshenq IV (ca. 783–777)
Osorkon III (ca. 777–749)
Takelot III (ca. 754–734)
Rudamon (ca. 734–731)
Iuput II (ca. 731–720)
Shoshenq VI (ca. 720–715) (identifi
cation uncertain)
Twenty-fourth Dynasty (ca. 730–715);
capital at Sais
Tefnakht I (ca. 727–720)
Bakenrenef (ca. 720–715)
Twenty-fifth (Kushite) Dynasty (ca.
747–656) (contemporaneous with part
of Twenty-third and Twenty-fourth
Dynasties)
Piye (ca. 747–716)
Shabaka (ca. 716–702)
Shebitku (ca. 702–690)
Taharka (ca. 690–664)
Tantamani (ca. 664–656)

Late Period (664–332)
Twenty-sixth Dynasty (664–525); capital
at Sais
Psammetichus I (664–610)—ruled
over all Egypt beginning in 656
Nekho II (610–595)
Psammetichus II (595–589)
Apries (589–570)
Amasis (570–526)
Psammetichus III (526–525)
Twenty-seventh (Persian) Dynasty
(525–404); capital at Susa and Per-
sopolis
Cambyses (525–522)
Darius I (522–486)
Xerxes (486–465)
Artaxerxes I (465–424)

Darius II (424–405)
Artaxerxes II (405–359)
Twenty-eighth Dynasty (404–399);
capital at Sais
Amyrtaios (404–399)
Twenty-ninth Dynasty (398–378);
capital at Mendes
Nepherites I (398–393)
Muthis I (?) (393–391)
Psammuthis (391–390)
Hakoris (390–378)
Nepherites II (378)
Thirtieth Dynasty (378–341); capital
at Sebennytos
Nectanebo I (378–360)
Teos (361–359)
Nectanebo II (359–341)
Thirty-first Dynasty (343–332); second
Persian domination
Artaxerxes III (343–338)
Arses (338–336)
Darius III (336–332)

Macedonian Kings (332–305)
Alexander the Great (332–323)
Philip Arrhidaeus (323–317)
(Ptolemy Lagos rules as satrap)
Alexander IV, son of Roxana
(317–305)

Ptolemaic Dynasty (305–30)
Ptolemy I Soter (305–285)
Ptolemy II Philadelphus (285–246)
Ptolemy III Euergetes I (246–221)
Ptolemy IV Philopator (221–205)
Ptolemy V Epiphanes (205–180)
Ptolemy VI Philometor (180–145)
Ptolemy VII Neos Philopator (145)
Ptolemy VIII Euergetes II (145–116)
Ptolemy IX Soter II (116–107)
Ptolemy X Alexander (107–88)
Ptolemy IX (again) (88–81)
Ptolemy XI Alexander (81–80)
Ptolemy XII Neos Dionysus
[Auletes] (80–51)
Cleopatra VII Philopator (51–30)

Roman Empire (30 B.C.E.–323 C.E.)

Byzantine Period (323–641 C.E.)

Abbreviations

BACE—*Bulletin of the Australian Centre for Egyptology*
BSEG—*Bulletin de la Société d'Égyptologie de Genève*
BSFE—*Bulletin de la Société Française d'Égyptologie*
CdE—*Chronique d'Égypte*
DiscEg—*Discussions in Egyptology*
ET—*Études et Travaux*
GM—*Göttinger Miszellen*
JARCE—*Journal of the American Research Center in Egypt*
JEA—*Journal of Egyptian Archaeology*
JNES—*Journal of Near Eastern Studies*
Klio—*Klio*
KMT—*K.M.T. A Modern Journal of Ancient Egypt*
MDAIK—*Mitteilungen des Deutschen Archäologischen Instituts, Abteilung Kairo*
Or—*Orientalia, new series*
RdE—*Revue d'Égyptologie*
SAK—*Studien zur altägyptischen Kultur*
ZÄS—*Zeitschrift für Ägyptische Sprache und Altertumskunde*

Bibliography

Aldred, C. *Akhenaten and Nefertiti*. New York, 1973.

Allam, S. Quelques aspects du mariage dans l'Égypte ancienne. *JEA* 67, 1981, pp. 116–135.

Allam, S. Die Stellung der Frau im alten Ägypten. *Bibliotheca Orientalis* 26, 1969, pp. 155–159.

Allen, J. P. Akhenaten's Mystery Coregent and Successor. *Amarna Letters* 1, 1991, pp. 74–85.

Arnold, D. *The Royal Women of Amarna: Images of Beauty from Ancient Egypt*. New York, 1996.

Assmann, J. Neith spricht als Mutter und Sarg. *MDAIK* 28, 1972, pp. 115–139.

Assmann, J. Die Zeugung des Sohnes: Bild, Spiel, Erzählung und das Problem des ägyptischen Mythos. In J. Assmann, W. Burkert, and F. Stolz, eds., *Funktionen und Leistungen des Mythos: Drei altorientalische Beispiele*, pp. 13–61. Freiburg-Göttingen, 1982.

Atiya, N. *Khul-Khal: Five Egyptian Women Tell Their Stories*. Cairo, American University in Cairo Press, 1984.

Bailey, E. Circumcision in Ancient Egypt. *BACE* 7, 1996, pp. 15–28.

Baines, J. Egyptian Twins. *Or* 54, 1985, pp. 461–482.

Baines, J. *Fecundity Figures*. Warminster, 1985.

Baines, J. Society, Morality, and Religious Practice. In B. E. Shafer, ed., *Religion in Ancient Egypt: Gods, Myths, and Personal Practice*, pp. 123–200. Ithaca, 1991.

Barta, W. Zur Reziprozität der homosexuellen Beziehungen zwischen Horus und Seth. *GM* 129, 1992, pp. 33–38.

Behlmer, H. Koptische Quellen zu (männlicher) "Homosexualität." *SAK* 28, 2000, pp. 27–55.

Berlandini, J. L' "acéphale" et le ritual de revirilisation. *Oudheidkundige Mededelingen uit het Rijksmuseum van Oudheden te Leiden* 73, 1993, pp. 29–37.

Bierbrier, M. I. Terms of Relationship at Deir el-Medina. *JEA* 66, 1980, pp. 100–107.

Boymel Kampen, N. *Sexuality in Ancient Art (Near East, Egypt, Greece and Italy).* Cambridge, 1996.

Bradley, K. Sexual Regulations in Wet-Nursing Contracts from Roman Egypt. *Klio* 62, 1980, pp. 321–325.

Broze, M. Aphrodite, Hathor, Eve, Marie, et Barbélo: à propos du langage mythique des textes de Nag Hammadi. *Kernos: Revue internationale et pluridisciplinaire de religion grecque antique* 7, 1994, pp. 47–57.

Broze, M. *Les aventures d'Horus et Seth dans le Papyrus Chester Beatty I.* Orientalia Lovaniensia Analecta 76. Louvain, 1996.

Broze, M. La création du monde et l'opposition *sdm.f/sdm.n.f* dans le temple d'Esna. *RdE* 44, 1993, pp. 3–10.

Broze, M. Le roi, les dieux, et la conjuration: Ramsès IV et la conjuration du Harem. In *Scriba IV, à la mémoire de Jan Quaegebeur,* pp. 23–24. Louvain, 1997.

Brunner, H. *Die Geburt des Gottkönigs: Studien zur Überlieferung eines altägyptischen Mythos.* Wiesbaden, 1964.

Brunner-Traut, E. Gravidenflasche: Das Salben des Mutterleibes. In *Archäologie und Altes Testament—Festschrift für Kurt Galling zum 8. Januar 1970,* pp. 35–48. Tübingen, 1970.

Brunner-Traut, E. Das Muttermilchkrüglein: Ammen mit Stillumhang und Mondamulett. *Die Welt des Orients: Wissenschaftliche Beiträge zur Kunde des Morgenlandes* 5, 1969–1970, pp. 145–164.

Brunner-Traut, E. Die Stellung der Frau im Alten Ägypten. *Saeculum: Jahrbuch für Universalgeschichte* 38, 1987, pp. 312–335.

Brunner-Traut, E. *Der Tanz im Alten Ägypten nach bildlichen und inschriftlichen Zeugnissen.* Glückstadt, 1992.

Brunner-Traut, E. Die Wochenlaube. *Mitteilungen des Instituts für Orientforschung der Deutschen Akademie der Wissenschaften zu Berlin* 3, 1955, pp. 11–30.

Bryan, B. M. The Etymology of *hnr* "Group of Musical Performers." *Bulletin of the Egyptological Seminar* 4, 1982, pp. 35–54.

Buchberger, H. Sexualität und Harfenspiel: Notizen zur "sexuellen" Konnotation der altägyptischen Ikonographie. *GM* 66, 1983, pp. 11–43.

Bulté, J. *Talismans égyptiens d'heureuse maternité: "Faïence" bleu-vert à pois foncés.* Paris, 1991.

Capel, A. K., and G. E. Markoe, eds. *Mistress of the House, Mistress of Heaven: Women in Ancient Egypt.* New York, 1996.

Castillejo, A. O. *Akhenaton: El Reformador homosexual.* Valencia, 1995.

Černý, J. Consanguineous Marriages in Pharaonic Egypt. *JEA* 40, 1954, pp. 23–29.

Černý, J., and T. F. Peet. A Marriage Settlement of the Twentieth Dynasty. *JEA* 13, 1927, pp. 30–39.

Chebel, M. *Histoire de la circoncision des origines à nos jours.* Paris, 1992.

Cole, D. The Role of Women in the Medical Practice of Ancient Egypt. *DiscEg* 9, 1987, pp. 25–29.

Cruz-Uribe, E. A New Look at the Adoption Papyrus. *JEA* 74, 1988, pp. 220–223.

Dasen, V. *Dwarfs in Ancient Egypt and Greece.* Oxford, 1993.

Daumas, F. *Les mammisis des temples égyptiens.* Paris, 1958.

Defossez, M. Les laitues de Min. *SAK* 12, 1985, pp. 1–4.

Derchain, P. *Hathor Quadrifrons: Recherches sur la syntaxe d'un mythe égyptien.* Istanbul, 1972.

Derchain, P. Le lotus, la mandragore, et le perséa. *CdE* 50, 1975, p. 65–86.

Derchain, P. Observations sur les Erotica. In G. T. Martin, ed., *The Sacred Animal Necropolis at North Saqqâra: The Southern Dependencies of the Main Temple Complex*, pp. 166–170. London, 1981.

Derchain, P. La perruque et le cristal. *SAK* 2, 1975, pp. 55–74.

Desroches-Noblecourt, C. *Amours et fureurs de la Lointaine.* Paris, 1995.

Desroches-Noblecourt, C. *La femme au temps des Pharaons.* Paris, 1986.

Dieleman, J. Fear of Women? Representations of Women in Demotic Wisdom Texts. *SAK* 25, 1998, pp. 7–46.

Dijk, J. van. The Nocturnal Wanderings of King Neferkare. In C. Berger et al., eds., *Hommages à Jean Leclant*, vol. 4, pp. 387–393. Cairo, 1994.

Drenkhahn, R. Bemerkungen zu dem Titel *ḥkr.t nswt. SAK* 4, 1976, pp. 59–67.

Dynes, W. R., and S. Donaldson, eds. Homosexuality in the Ancient World. *Studies in Homosexuality* 1, 1992, pp. 340–358.

Edgerton, W. F. *Notes on Egyptian marriage, Chiefly in the Ptolemaic Period.* Chicago, 1931.

Eissa, A. Eine metaphorische Geste der sexuellen Vereinigung. *GM* 184, 2001, pp. 7–13.

Erman, A. *Zaubersprüche für Mutter und Kind aus dem Papyrus 3207 des Berliner Museums.* Berlin, 1901.

Eyre, C. Crime and Adultery in Ancient Egypt. *JEA* 70, 1984, pp. 92–105.

La Femme au temps des pharaons. Musées Royaux d'Art et d'Histoire de Bruxelles, Mainz, 1985.

Feucht, E. *Das Kind im Alten Ägypten: Die Stellung des Kindes in Familie und Gesellschaft nach altägyptischen Texten und Darstellungen.* Frankfurt, 1995.

Fischer, H. G. An Eleventh Dynasty Couple Holding the Sign of Life. *ZÄS* 100, 1973, pp. 16–28.

Fischer, H. G. *Egyptian Women of the Old Kingdom and the Heracleopolite Period.* New York, 1989.

Foster, J. L. *Love Songs of the New Kingdom.* Austin, 1974.

Fowler, B. H. *Love Lyrics of Ancient Egypt.* Chapel Hill, 1994.

Fox, M. V. "Love" in the Love Songs. *JEA* 67, 1981, pp. 181–182.

Fox, M. V. *The Song of Songs and the Ancient Egyptian Love Songs.* Madison, Wisc., 1985.

Franke, D. *Altägyptische Verwandtschaftsbezeichnungen im Mittleren Reich.* Hamburg, 1983.

Fürstauer, J. *Eros im Alten Orient: Eine vergleichende Darstellung der Erotik der Völker im Alten Orient.* Stuttgart, 1965.

Galvin, M. The Hereditary Status of the Titles of the Cult of Hathor. *JEA* 70, 1984, pp. 42–49.

Galvin, M. The Priestesses of Hathor in the Old Kingdom and the 1st Intermediate Period. Ph.D. dissertation, Brandeis University, 1981.

Geheimnisvolle Königin Hatschepsut: Ägyptische Kunst des 15. Jahrhunderts v. Chr. Exhibition catalogue, National Museum. Warsaw, 1997.

Germer, R. Die Bedeutung des Lattichs als Pflanze des Min. *SAK* 8, 1980, pp. 85–87.

Gitton, M. *Les Divines Épouses de la 18ᵉ dynastie.* Besançon, 1984.

Gitton, M. *L'Épouse du dieu Ahmes Néfertary*. Paris, 1975.

Gitton, M. Le Rôle des femmes dans le clergé d'Amon à la 18ᵉ dynastie. *BSFE* 75, 1976, pp. 31–46.

Goddesses and Women. *KMT* 5(4), 1994–1995.

Goedicke, H. Unrecognized Sportings. *JARCE* 6, 1967, pp. 97–102.

Goelet, O. Nudity in Ancient Egypt. *Notes in the History of Art* 12(2), 1993, pp. 20–31.

Griffiths, J. G. *The Conflict of Horus and Seth from Egyptian and Classical Sources*. Liverpool, 1960.

Griffiths, J. G. *Plutarch's de Iside et Osiride*. Cardiff, 1970.

Griffiths, J. G. Love as a Disease. In *Studies in Egyptology Presented to Miriam Lichtheim*, vol. 1, pp. 349–364. Jerusalem, 1990.

Grimm, A., and S. Schoske. *Das Geheimnis des goldenen Sarges: Echnaton und das Ende der Amarnazeit*. Munich, 2001.

Guglielmi, W. Lachen und Weinen in Ethik, Kult und Mythos der Ägypter. *CdE* 55, 1980, pp. 69–86.

Guilhou, N. *La vieillesse des dieux*. Montpellier, 1989.

Guilmot, M. Lettre à une épouse défunte (Pap. Leiden I, 371). *ZÄS* 99, 1973, pp. 94–103.

Harari, I. La Capacité juridique de la femme au Nouvel Empire. *Revue Internationale des Droits de l'Antiquité* 30, 1983, pp. 41–54.

Hatchepsout, Femme Pharaon. *Dossiers d'Archéologie: Documents* (Paris-Dijon), 1993.

Hawass, Z. *Silent Images: Women in Pharaonic Egypt*. Cairo 1995; New York, 2000.

Helck, H. W. Die Tochterheirat ägyptischer Könige. *CdE* 44(87), 1969, pp. 22–26.

Hopkins, M. K. Brother–Sister Marriage in Roman Egypt. *Comparative Studies in Society and History* 22, 1980, pp. 303–355.

Hornung, E. *Conceptions of God in Ancient Egypt: The One and the Many*. Ithaca, 1982.

Houlihan, P. G. *Wit and Humour in Ancient Egypt*. London, 2001.

Ikram, S. Domestic Shrines and the Cult of the Royal Family at el-Amarna. *JEA* 75, 1989, pp. 89–101.

Jacq, C. *Die Ägypterinnen—Eine Kulturgeschichte*. Düsseldorf, 1998.

Janssen, J. J. Marriage Problems and Public Reactions. In *Pyramid Studies and Other Essays Presented to I.E.S. Edwards*, pp. 134–137. London, 1988.

Janssen, R. M., and J. J. Janssen. *Growing up in Ancient Egypt*. London, 1996.

Junge, F. Isis und die ägyptischen Mysterien. In *Aspekte der spätägyptischen Religion*, pp. 93–115. Wiesbaden, 1979.

Kadish, G. E. Eunuchs in Ancient Egypt? In *Studies in Honor of John A. Wilson*, pp. 55–62. Chicago, 1969.

Kanawati, N. Polygamy in the Old Kingdom of Egypt. *SAK* 4, 1976, pp. 149–160.

Kemp, B. J. *Ancient Egypt: Anatomy of a Civilization*. London, 1989.

Kemp, B. J. The Harim-Palace at Medinet el-Ghurab. *ZÄS* 105, 1978, pp. 122–133.

Kennedy, J. Circumcision and Excision in Egyptian Nubia. *Man* 5, 1970, pp. 175–191.

Kessler, D. Der satirisch-erotische Papyrus Turin 55001 und das "Verbringen des schönen Tages." *SAK* 15, 1988, pp. 171–196.

Krah, K. *Die Harfe im pharaonischen Ägypten: ihre Entwicklung und Funktion*. Göttingen, 1991.

Index

and god's wives of Amun, 98; and
Hathor, *108*; as head priest, 20; Horus as
prototype for, viii, 4, 17, 91, 92, 93, 95;
and life-giving male vital force, 4; and
Min festival, 14, 15, 16, 17, 18; and
monogamy, 104; mourning for, 138;
Osiris identified with, 56; and polygamy,
100; and role of queen, 100–104; and
royal mother, 18, 79, 81, 84, 93–96. *See
also specific pharaohs*
Philae, 18, 91, 92
Plutarch, 26, 27, 55, 56
Poetry: and associations with vagina, 38;
eroticism in, vii, 116–20; and marriage, xi,
119; and representations of women, 137
Politics: and birth houses, 92; and consorts
of Amun, 8; and divine birth of
pharaoh, 90, 94; and god's wives of
Amun, 97, 99, 104; and harems,
100–103; and Hatshepsut's legitimacy as
ruler, 83–84, 88; and intermingling of
cultural mores, xi; and Min festival, 15,
16; and queens, 103; and royal mother,
95. *See also* Propaganda
Polychromy. *See* Coloristic conventions
Polygamy, xi, 100
Potency: and aphrodisiacs, 9, 119, 139; and
bull, *106*; and homosexuality, 34; and
Kemwer, 62; and Khnum, 42; and magic,
139; and Min, 17, 18; and Osiris, 56; and
phallus, 27; and poetry, 119; and posthu-
mous life, 9; and preservation of life, viii
Predynastic Period, 10, 75, 139
Pregnancy: alabaster vessel for, *109*, 141;
and Bes, viii, 140; determination of, 140,
143; and Egyptian art, 86; and miscar-
riage, 141, 143; prevention of, 139–40,
143; and public baths, 62
Priapus, 18
Priestesses: and god's wives of Amun, 95,
96–97, 99; and hand of the god, 8; and
harems of gods, 99, 100; and ritual pu-
rity, 138; and sexual relations with ugly
man, 120
Priests: and circumcision, 137, 144–45; and

clean-shaven heads, 114; and Min festi-
val, 14; pharaoh as head priest, 20; and
sexual relations, 138; and Turin Papyrus,
ix
Primeval mound, 5, 6, 7, 40, 45
Propaganda: and divine birth of pharaoh, 84,
90; and fertility cult, 63; and Min festival,
15, 16, 18; and personification of Nile,
41–42; and pharaoh as part of divine triad,
28–29; and sacred cow as wet nurse, 78;
and theology, 28. *See also* Politics
Property, and marriage, xi, 138, 146, 149
Prudery, viii, x
Psammetichus I (pharaoh), 98
Psammetichus II (pharaoh), 99
Ptah: and Apis, 76, 78; creation of, 40; and
divine triad, 29; and Memphite theolog-
ical system, 43, 44; merger of theological
systems, 45; and mutual visiting of
deities, 90
Ptahhotep (vizier), 149–50
Ptolemaic Period: and chamber of Bes,
viii; and daily life, xiv; and divine birth
of pharaoh, 90, 91; and fertility cult, xv;
and frog-warrior, 89; and god's wives of
Amun, 99; and Hermopolitan theologi-
cal system, 39; and historical context, x;
and homosexuality, 35; and Isis, 62, 77;
and marriage, 145; and Memphite theo-
logical system, 44–45; and Min festival,
16; and mutual visiting of deities, 90;
and Nut, 21; religion of, 2; and repre-
sentation of Horus child, xiii
Ptolemy III (pharaoh), 59
Ptolemy VI (pharaoh), xv, 63, *73*
Ptolemy VIII (pharaoh), 63
Public baths, xv–xvi, 59, 62–65, *73, 74,*
139, cp
Punt, 11–12
Pyramid Texts: and Apis, 76; and Egyptian
religion, 3; and Heliopolitan theological
system, 5; and homosexual episode of
Horus and Seth, xiii, xiv, 30–31, 32, 34;
and Nut, 22, 23
Pyramids, 2, 3, 7, 32, 94